W9-CYY-280

IMAGES
of America

BLOOMINGDALE

IMAGES
of America

BLOOMINGDALE

Rosemarie Onwukwe

ARCADIA
PUBLISHING

Copyright © 2010 by Rosemarie Onwukwe
ISBN 978-0-7385-6610-8

Published by Arcadia Publishing
Charleston SC, Chicago IL, Portsmouth NH, San Francisco CA

Printed in the United States of America

Library of Congress Control Number: 2009943480

For all general information contact Arcadia Publishing at:
Telephone 843-853-2070
Fax 843-853-0044
E-mail sales@arcadiapublishing.com
For customer service and orders:
Toll-Free 1-888-313-2665

Visit us on the Internet at www.arcadiapublishing.com

This book is written in loving memory of my late husband,
Emmanuel Onwukwe, who was a proud resident of
Bloomingdale, a participant in the "orange hats" security patrols,
and member of the Bloomingdale Civic Association.

BLOOMINGDALE POEM (ORIGINAL WRITER UNKNOWN)

How dear to this heart are the scenes of my childhood
When fond recollection recalls them from view—
The orchard, the meadow, the deep tangled wildwood
And every loved spot which my infancy knew.

Dear Bloomingdale—dear old Granny—all gone.

—Retold to Edward F. Beale on August 26,
1906, and received by Evan McGowen

CONTENTS

ACKNOWLEDGMENTS

To my mother, Lillian Durodola, a fellow writer, thanks for your editorial skills and patience and many prayers. My daughter Nnenna, my trusty assistant and future writer, thanks for the hours of scanning, copying, sorting, and calm. My son David, thanks for the words of encouragement. To my extended family, Carroll, James II, and Lorraine, you're the best and I love you all, and Lorraine, thanks for the morning pep talks and text messages. Thanks to my late father, James Durodola, who passed away July 2, 2009—finally I finished this; you would be so proud. Aunt Raine, Uncle Bob, Aunt Marion, and Aunt Al, thanks for believing in me. To my father-in-law, Samuel Onwukwe, and mother-in-law, Molly Onwukwe, and all my brothers-in-law and sisters-in-law and cousins-in-law, thanks for your support.

My friends, I truly appreciate your support. There are too many to mention from Washington, D.C., to Maryland, Virginia, North Carolina, Delaware, Chicago, Arkansas, Rhode Island, Seattle, Texas, and Nigeria. All my fellow widows in my support group, your encouragement helped me more than you will ever realize. I appreciate the many prayers for me and this project from both family and friends and members at Israel Metropolitan CME Church.

Suzanne Des Maires, thank for your months or research, beautiful sketches of buildings, and constant encouragement. Many thanks to Jo Nicholson for sharing her family's history and to David Nicholson for putting together the booklet *Remembering 110*. To the entire Simons family and descendants, thank you so much for keeping the photographs and memories of your family and legacy with us in Bloomingdale. And Debbie Singletary truly saved the day coming up with the last-minute classic photographs (some 100 years old) in order for me to make my deadline—many, many thanks!

Thanks to Evan Randolph, descendant of the Beale family for your patience and time to help retrace the history of Bloomingdale.

To people in my neighborhood: Advisory Neighborhood Commission (ANC) commissioner John Salatti, thanks for being there for me, calling up troops, and providing pictures and research—I really appreciate it. Elle Glitin and Hugh Youngblood, thank you. Jenifer Simpson, thank you for sharing over 30 years of great pictures of the Bloomingdale neighborhood. Diane Barnes, Cleopatra Jones, the Charles family, Nelson Marr, the Bryan family at the historic Anna Cooper house, famous photographer Jason Miccolo Johnson, Natalie Hopkinson and family, and Gerald Duvall from the Bloomingdale Inn, thank you for sharing your history in the neighborhood. Scott Roberts, thanks for getting the word out to people of Bloomingdale. Thank you Jason Miccolo Johnson for your photographs.

Faye Haskins in the Washingtoniana Division of the Martin Luther King Library, thanks for all the hours of your time pulling pictures at the library.

Photocopying shops like Staples on Georgia Avenue and Penn Camera in Laurel, thanks for taking my last-minute requests.

Paul Kelsey Williams of Kelsey and Associates, thanks for the great work you have done searching for information concerning the history of our Washington, D.C., neighborhoods and sharing pictures. Many thanks to MaryAnn Wilmer for rescuing me at the last minute.

To Robert Brannum, 2010 president of the Bloomingdale Civic Association, thank you for all your help.

INTRODUCTION

One of the hardest parts about writing this book was figuring out how to define where Bloomingdale was. One of the basic issues is that Bloomingdale, LeDroit Park, Edgewood, and Eckington are closely linked neighborhoods with constantly changing boundaries. Because of this, there are pictures that may be from LeDroit Park but at the time, they were part of or claimed to be part of Bloomingdale.

With redistricting, parts of Bloomingdale are now LeDroit Park, but still Bloomingdale remains the little sliver of land that remains a proud part of the D.C. heritage.

I also added some pictures from Howard University because of how important this black university was and still is to Bloomingdale. Howard University students still live in Bloomingdale in large numbers, and in the mornings you can see students walking to Howard, as it is just a few blocks away. Some graduates from Howard University ended up moving back to the neighborhood, including my late husband, Emmanuel.

In addition to Howard University, the close proximity to three major hospitals—Children's Hospital, Washington Hospital Center, and Veterans Hospital and National Rehab Center—all add employment and easy access to medical facilities.

The Bloomingdale Inn is another historic building located in Bloomingdale. Gerald Duvall, the current caretaker at Bloomingdale Inn, mentioned that the Bloomingdale Inn was formerly known as the Stevens House, set up by the Catholic diocese for African American parishioners during the period of segregated churches. Some of the rooms still feature a worship area on a small platform. Mirrors hung for the priest were set up to be three-quarter height so that the priest could not look at his face to discourage vanity.

When the inn was renovated, the owners were able to add an adjoining row house to increase the width and overall square footage of the Bloomingdale Inn.

Bloomingdale Inn provides a wonderful bed-and-breakfast and often is fully booked, as visitors enjoy this location for meetings and conferences held at Howard University and the medical locations.

North Capitol and First Streets are major roads going through Bloomingdale. With metro buses on all major roads and side streets, the neighborhood of Bloomingdale is quite attractive. Howard University's green line is the closest metro to the Bloomingdale neighborhood, although the red lines of Union Station and Catholic University are also quite popular.

A VERY BRIEF HISTORY OF BLOOMINGDALE

The boundaries of Bloomingdale came from several large estates and lie between the LeDroit Park Historic District and the former small village of Eckington and also near Edgewood. The neighborhood name has many different histories associated with it. One is that it came from the beautiful and fragrant flowers that bloomed from spring to fall. Another history claims that the name was derived from the Bloomingdale estate purchased by George Beale, a decorated officer who bought the estate in 1823. The former Boundary Street today is Florida Avenue and was the dividing line between paved, planned streets that were laid out in the original city plan. The country, on the other hand, was where the landowners kept orchards, large country estates, and a mixture some other commercial properties. As time went on, the unique Victorian style of architecture was designed to give middle-class families the opportunity to purchase a decent home.

Initially the area was used for train yards and transportation to and from the city of Washington D.C. In 1889, Silas Daish built a large flourmill at the corner of Third Street and Florida Avenue. At the time, there were only two flourmills in Washington, D.C. The industrial activity also

included the McMillan Park sand filtration site, a prominent structure in the Bloomingdale neighborhood and part of a chain of public green spaces established in Senator James McMillan's 1901 plan for beautifying Washington. The grounds were designed by landscape architect Frederick Law Olmsted Jr.

In the late 1890s, Bloomingdale began to change, as Washington, D.C., began to experience the pressures of growing pains from the huge influx of workers and freedmen after the Civil War. Developers and landowners began to see the potential of the orchards and farmlands, and as a result, Bloomingdale would develop and change, especially in the area between Eckington and LeDroit Park. Roads that would link to the grid system of Washington's streets were improved in order to introduce extensions of the popular trolley lines.

In 1902, Rhode Island Avenue Methodist Episcopal Church built an elegant structure at the desirable corner of Rhode Island Avenue and First Street, NW. Now home to Mount Bethel Baptist Church, the original active congregation was founded by former slaves.

Developers like Harry Wardman, Francis Blundon, and S. H. Meyers built dozens of homes in the neighborhood in the first decade of the 20th century. The Gage School was the first neighborhood school and was built in 1904. Small businesses began to open, including a pharmacy and a barbershop. Additional churches were built as a religiously, ethnically, and racially diverse population moved into the area. The neighborhood had large Italian, Irish, German, Jewish, and African American populations even before neighboring LeDroit Park had integrated, but this was not without conflict. In 1948, a famous Supreme Court case, *Hurd v. Hodge*, held that enforcing racial and religious covenants restricting home ownership was unconstitutional. These pioneering Bloomingdale homeowners made it easier for all people to purchase property in this country.

Samuel Gompers, the founder of the AFL-CIO, built a house for himself in Bloomingdale in 1886. Chita Rivera, two-time Tony Award winner and six-time Tony Award nominee, grew up as Dolores Figueroa in the neighborhood on Flagler Place. The Barnett Aden Gallery was the first privately owned black gallery in the United States and one of Washington, D.C.'s principal art galleries when it opened in 1946.

Along with the rest of the city, Bloomingdale went through its own decline in the 1970s, 1980s, and 1990s, but since then, the neighborhood has been transformed, and more people have moved back to the city. Homes and buildings have gone through a lot of renovation, and new businesses are constantly opening. After decades, the empty Gage School was carefully turned into award-winning condominiums, called Parker Flats, that have retained the historic nature of the original school building. The community maintains active civic groups and organizations. Today Bloomingdale proudly maintains its close-knit, community-oriented character. Newer residents and longtime residents share a common interest in sharing and preserving Bloomingdale's rich and unique history.

One

EARLY YEARS IN BLOOMINGDALE
FROM THE 1800s

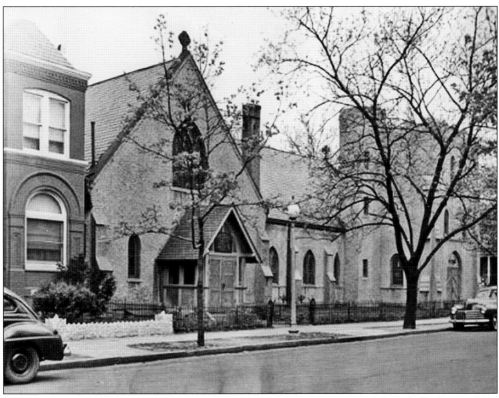

ST. GEORGE'S EPISCOPAL CHURCH IN BLOOMINGDALE, EARLY 1900s. In 1929, Sally Perry of the LeDroit Park community asked the Right Reverend James E. Freeman, bishop of Washington, if the community could have a church for black Episcopalians. Their first meeting was held in Mrs. Perry's home, then at 85 R Street, and when they had outgrown this location, they finally moved to the new St. George's location at Second and U Streets, where it still stands today.

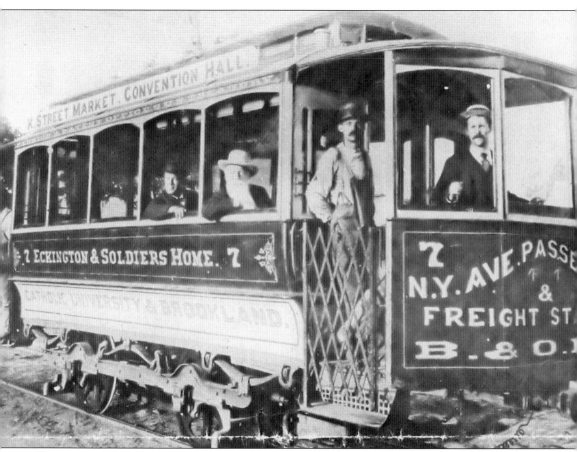

STREETCARS IN WASHINGTON, D.C., IN THE LATE 1800S. The invention of streetcars (often called trolley cars) changed many neighborhoods in Washington, D.C., including Bloomingdale. In the late 1800s, Bloomingdale was mainly farmland and was not developed. But as time went by and streetcars were set up, the area became more industrial. First train tracks were built in and around Washington, D.C., and then the streetcar lines were laid. Bloomingdale was a natural fit for the working class in the area, as the streetcars easily connected the neighborhoods to the downtown area. Here is a typical streetcar. (Courtesy of Washingtoniana Division, D.C. Public Library.)

2131 First Street, NW (Middle). A gentleman purchased an old album featuring some pictures from Bloomingdale. He found this picture and very kindly contacted the current owner of the home. This home, like many of the classic homes in D.C., has at least four levels. The homes are quite large on the inside, with high ceilings. This picture is believed to have been taken in 1910. (Courtesy of D. Delcher.)

Samuel Singleton, Age 11. Samuel is pictured in the living room of his house on First Street, NW. Samuel attended boarding school at Palmer Institute in Sedalia, North Carolina. He later married Lanita Lewis Singleton, who attended a similar boarding school in the early to mid-1940s named Holy Providence in Cornell Heights, Pennsylvania. (Courtesy of the Singleton family.)

ALBERT (CUBIE) MEADE AND FRIENDS IN BLOOMINGDALE ON FIRST STREET, NW, AROUND 1940.
Albert was the foster child of great-grandmother Lilla Alice Sears. He lived in the attic, and he
was an artist known for his abstract paintings. He used to take the children in the neighborhood
to the playground close by on Fourth and Bryant Street NW, across from K. C. Lewis Elementary
School. He also took them, along with their dogs, to the P Street "beach," which was a sandy park.
Albert met an untimely death in the early 1970s. (Courtesy of the Singleton family.)

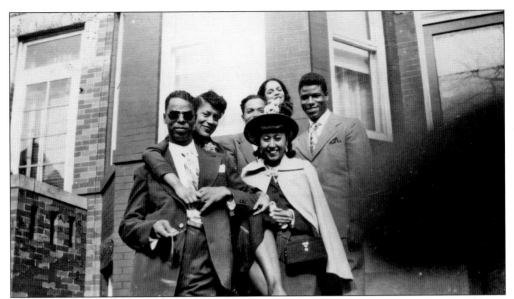

SAMUEL SINGLETON AND ALBERT MEADE WITH FRIENDS AND RELATIVES. Samuel enjoyed living in the neighborhood and all that Bloomingdale had to offer. His children and neighbors described him as kind and warmhearted. He looked out for neighbors and for the general upkeep of the neighborhood itself. (Courtesy of the Singleton family.)

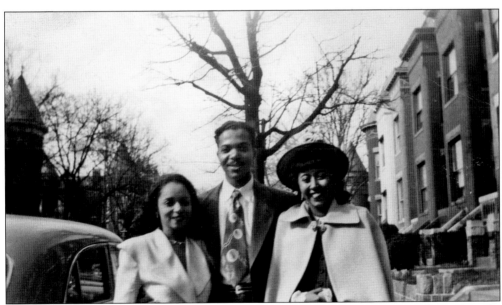

SINGLETON FAMILY PHOTOGRAPH IN BLOOMINGDALE, AROUND 1950. From left to right are Dorothy James Orr (cousin) and friends in the 1700 block of First Street, NW. Dorothy is now in her 80s and lives in White Plains, New York. She was formerly the commissioner of human rights under Rockefeller. (Courtesy of Debbie Singleton.)

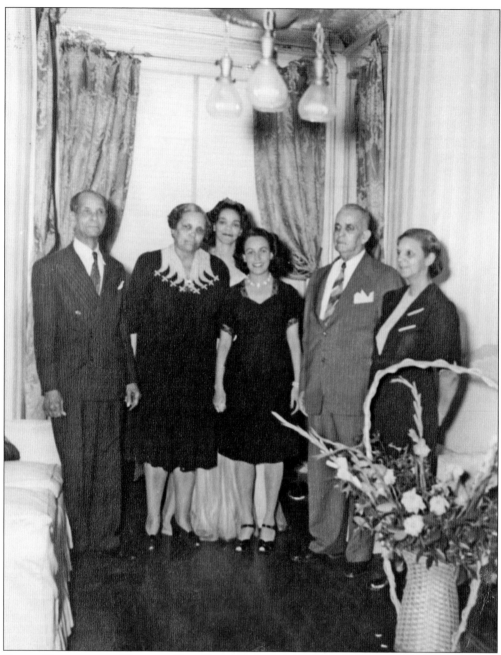

FAMILY PORTRAIT ON WEDDING DAY. Typically every important family event was held in the home. This included weddings, births, funerals, and year-round events like Thanksgiving dinner and Christmas celebration. One of the contributors remembers that after her grandmother died the family had her in the living room so family members and neighbors could pay their respects. (Courtesy of the Singleton family.)

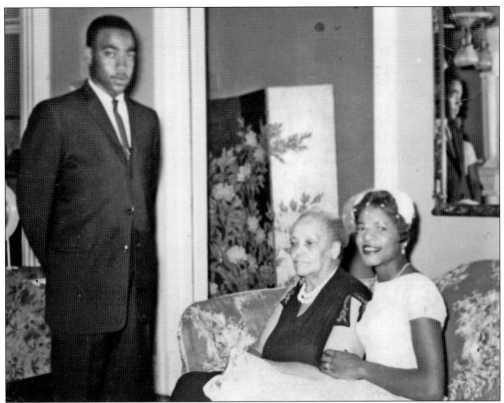

Lilla Alice Sears and Phyllis Poole (Foster Child). Phyllis was one of the many foster children under Lilla Alice. Phyllis was found abandoned in a vacant house by a policeman named Poole. This is Phyllis on her wedding day with her husband, David. (Courtesy of the Singleton family.)

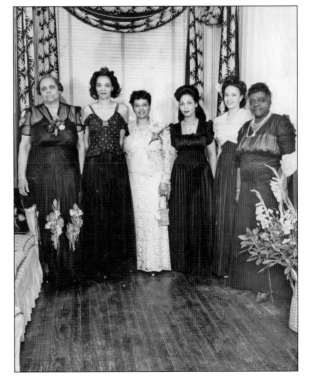

Singleton Family Members. From left to right are Debbie Singleton's great-grandmother Lilla Alice Sears, originally from Birmingham, Alabama; Eunice Eleanor Singleton (Debbie's grandmother); Fannie Ponder (a friend of Eunice); two unidentified friends; and Mary McLeod-Bethune (a friend of the family) who founded the National Council for Negro Women. (Courtesy of the Singleton family.)

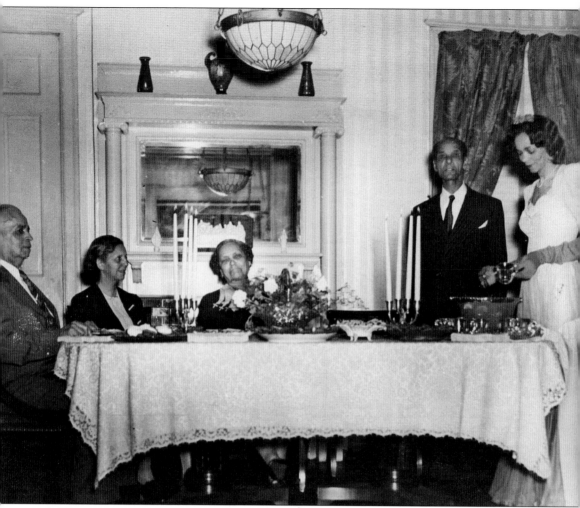

A WEDDING DAY IN BLOOMINGDALE. From left to right are Eunice Singleton's father, William Sears; his wife, Lilla Alice Sears; Lillia and Zebee Hicks, who were brother and sister and were originally from Birmingham; and the bride, Eunice Eleanor Singleton. (Courtesy of the Singleton family.)

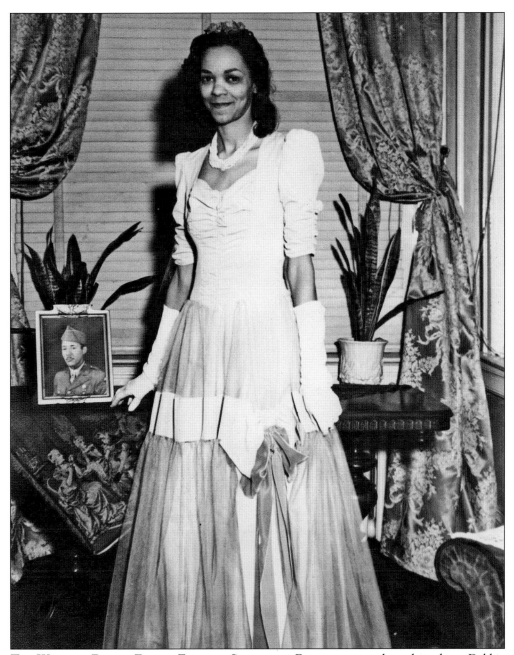

THE WEDDING DAY OF EUNICE ELEANOR SINGLETON. Eunice poses in her white dress. Debbie Singleton recalls how special events were held in the family home: weddings and funerals were all conducted in the living room of the house. The home was also used for all holiday events, including Thanksgiving, Christmas, birthday parties, and family events and get-togethers. (Courtesy of the Singleton family.)

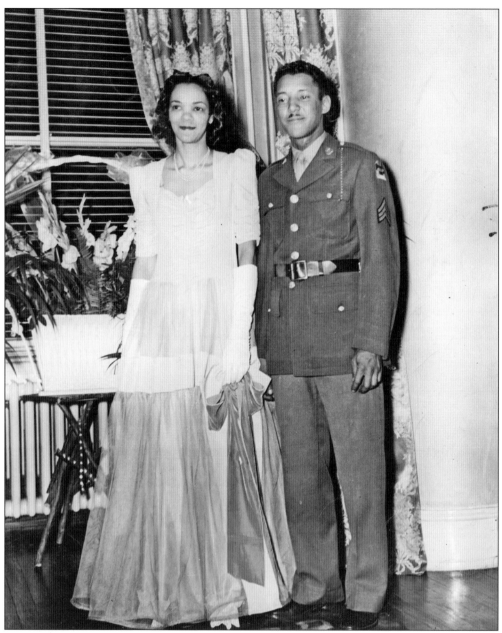

THE NEWLYWEDS POSE FOR A PICTURE ON THEIR WEDDING DAY. Wedding dresses like this one were often designed and sewn by family members who would spend hundreds of hours creating, designing, and sewing the intricate dresses. Wedding dresses were often handed down from generation to generation, with alterations and adjustments made for the new bride. (Courtesy of the Singleton family.)

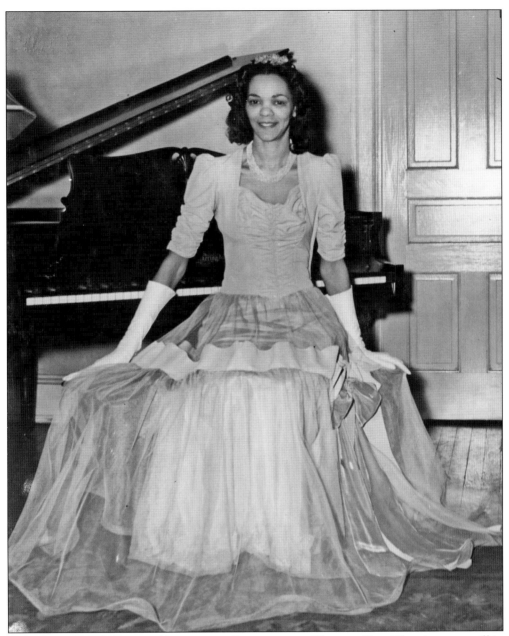

EUNICE ELEANOR SINGLETON POSES BY THE PIANO ON HER WEDDING DAY. The piano was still in this home in 2009. Children and grandchildren state that no one else really learned how to play the piano, but it was kept in the home anyway. The piano is a great backdrop for photographs. (Courtesy of the Singleton family.)

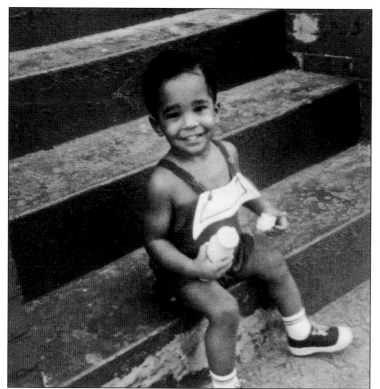

SAMUEL SINGLETON
II AS A CHILD IN
BLOOMINGDALE,
AROUND 1971.
Samuel is now 40
years old. He works
for the *Washington
Post* in Washington,
D.C. He was born
several years after the
previous youngest and
enjoyed many family
poses for photographs.
(Courtesy of the
Singleton family.)

SAMUEL SINGLETON
II RIDING HIS BIKE,
AROUND 1971.
Samuel enjoyed
the benefits of
living in such a
comfortable middle-
class neighborhood.
The Singleton
family was able to
preserve hundreds of
family photographs
through the years.
(Courtesy of the
Singleton family.)

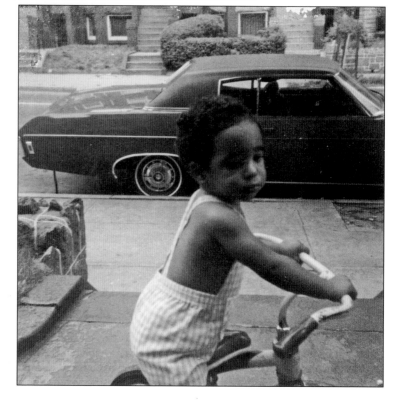

MICHELLE DEBORAH "DEBBIE" SINGLETON AND THEIR MOTHER, DONNA SINGLETON, ON FIRST STREET, NW, AROUND 1960. The two sisters are in front of their home in Bloomingdale. The convertible was their father Samuel's pride and joy. (Courtesy of the Singleton family.)

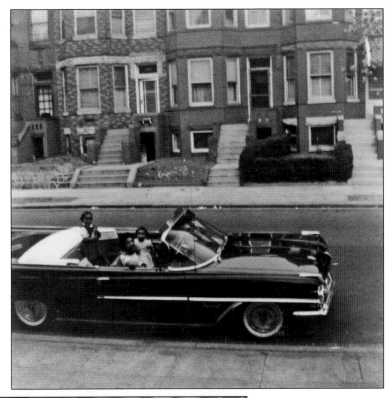

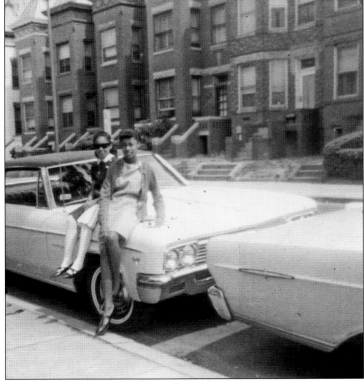

DONNA SINGLETON (LEFT) AND HER NEXT-DOOR NEIGHBOR JOYCE BATSON HARRIS, 1970s. Donna, who attended St. Martin's School, relaxes outside with neighbor Joyce (Batson) Harris, who attended Gage Elementary School, Shaw Junior High School, and Cardoza High School. The children and grandchildren said attending school in the different zones was a lot more relaxed than it was today. However, after school and during the holidays, everyone just enjoyed playing games and having fun together. (Courtesy of the Singleton family.)

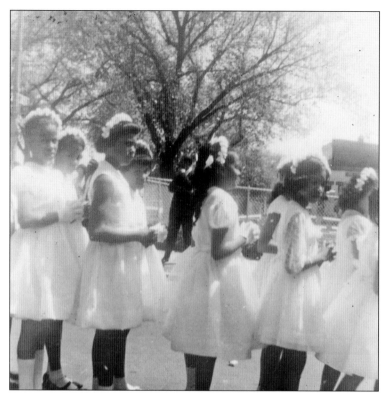

MAY DAY AT ST. MARTIN'S SCHOOL, 1966. The May queen was voted by the eighth-grade class. A crown of flowers was placed on the Holy Mother as well. St. Martin's educated many Bloomingdale, Eckington, Edgewood, and Le Droit Park residents; all these neighborhoods are adjacent to one another. (Courtesy of the Singleton family.)

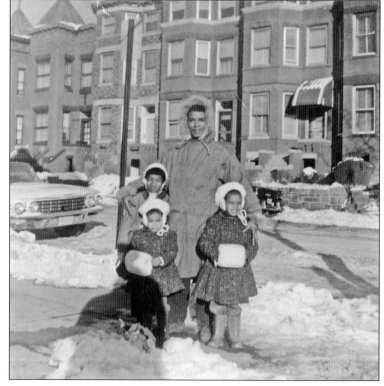

FAMILY AND FRIENDS ON A WINTER DAY, AROUND 1963. From left to right are Joyce Batson Harris, Donna, Albert Meade, and Debbie on a cold winter day. The girls had hand muffs. (Courtesy of the Singleton family.)

PHYLLIS POOLE WITH BABY DEBBIE SINGLETON, AUGUST 1957. Phyllis was a big help to the Singleton family. From helping wash and hang laundry to numerous household chores, Phyllis was there for the family. (Courtesy of the Singleton family.)

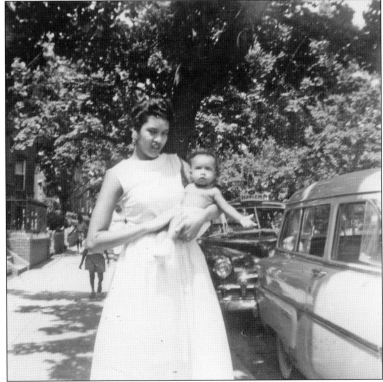

LANITA SINGLETON AND DAUGHTER DEBBIE. Lanita worked at the IRS for 20 years, but she waited until her children were in school full-time before she went back to the workforce. She thoroughly enjoyed her time at home with her children, and as they got older, she was happy to go back to work also. (Courtesy of the Singleton family.)

23

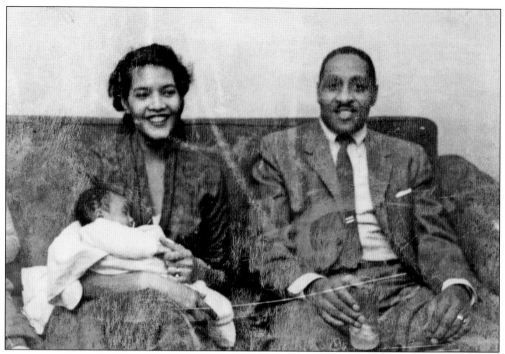

LANITA SINGLETON AND HER STEPFATHER, THEODORE HAWKINS. Family, including extended family, was very important to the Singleton family. They kept a record of their family history along with many valuable pictures that they wish to hand down to future generations. (Courtesy of the Singleton family.)

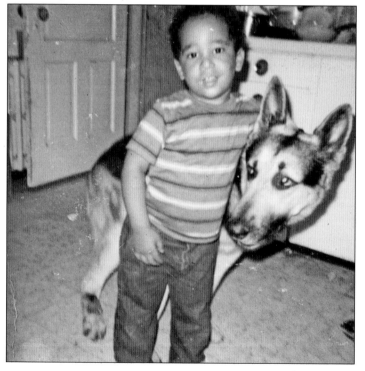

THOR THE DOG, NAMED AFTER THE NORSE GOD OF THUNDER, AROUND 1973. Funnily enough, the children liked the name Thor without understanding what his name meant. Unfortunately, Thor was petrified of thunder and lightning and would hide with Samuel Singleton II during storms. (Courtesy of the Singleton family.)

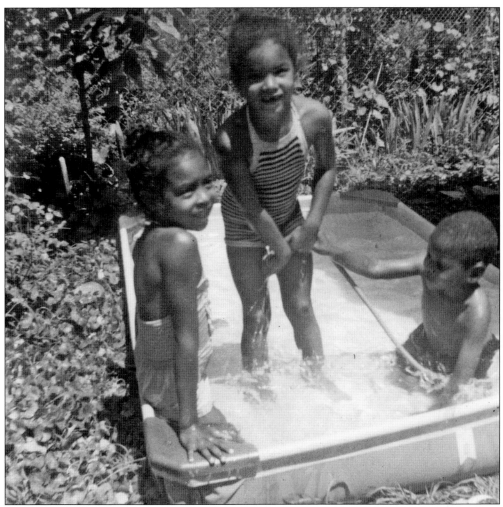

THE NICHOLSON, SINGLETON, AND THE SIMONS FAMILIES. The Simons, Nicholson, and Singleton families were friends who lived in the same neighborhood. From left to right, Debbie and Donna Singleton and William Nicholson (from 110 S Street, NW, now deceased) enjoy the paddling pool on a hot day. The Nicholson family and the Simons family used to play together. Their homes backed up into an L in the alley. There were many neighbors in this block who were former teachers and educators and who looked out for the children. (Courtesy of the Singleton family.)

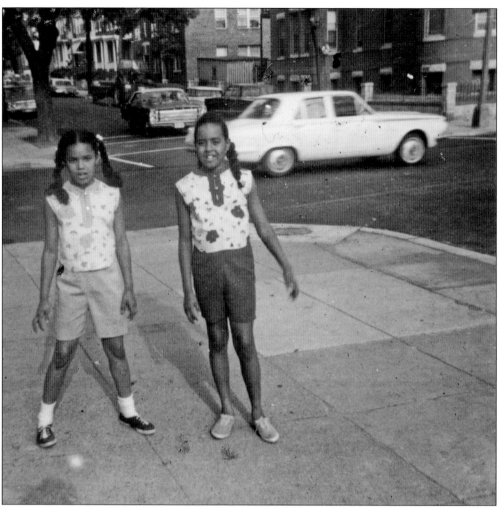

SISTERS DONNA (LEFT) AND DEBBIE IN BLOOMINGDALE. The two sisters here were playing on the corner of First and Randolph Streets, NW. Debbie recalls that when one of the children got into mischief, any of the adults were free to correct them, and by the time they got home, their parents had already heard about their misdeeds. (Courtesy of the Singleton family.)

ANITA HAWKINS, DONNA, AND DEBBIE, AROUND 1967. Pictured here are Donna (at right, now the deputy director for the D.C. Office on Aging) and Debbie, an educator and former teacher who currently works with a social company and the proud parent of two sons. Debbie still lives in the family home with her brother. (Courtesy of the Singleton family.)

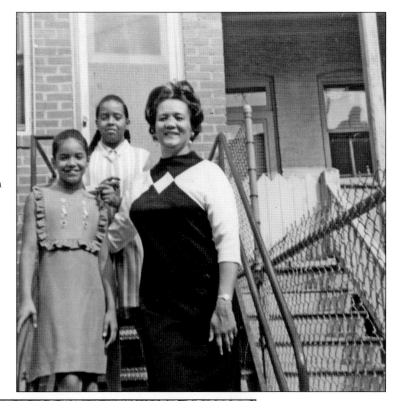

DONNA AND THOR IN THE BACKYARD OF THEIR BLOOMINGDALE HOME AROUND 1968. The backyards in the Bloomingdale neighborhood provided a great deal of enjoyment and fun for the children and adults. There was no fear because the areas were safe and due to the structures of the row houses. Parents could easily keep an eye on not only their children but also the neighborhood children. (Courtesy of the Singleton family.)

27

KIM CONNER OUTSIDE ST. MARTIN'S CHURCH, AROUND 1967. Kim was one of Debbie Singleton's classmates. Many of these classmates from St. Martin's School not only recall each other's names but still manage to keep in touch with each other. These children enjoyed an excellent education, and many of them went on to be doctors, lawyers, educators, and civil servants in society. (Courtesy of the Singleton family.)

DONNA ON FIRST STREET, NW, 1968. The trees created great shade in the summertime and framed a pretty picture with the sidewalk. Neighbors recall that many of the trees in Bloomingdale were quite prominent, and on some streets, they were perfectly lined up like an avenue. (Courtesy of the Singleton family.)

DONNA STANDING OUTSIDE THE YARD, AROUND 1968. This picture shows the beautiful brickwork surrounding the yard. This brickwork showcases skilled labor by masons and is increasingly difficult to find in this neighborhood. (Courtesy of the Singleton family.)

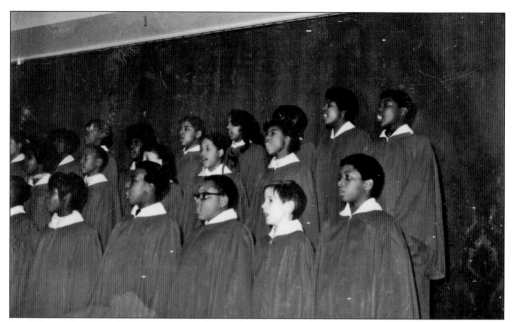

St. Martin's Glee Club, 1970s. A glee club is a group of male and/or female voices. The word originally comes from singing short songs or "glees" in groups of threes or fours. Debbie was a member of the club from the fifth grade to the eighth grade. Debbie was about 12 years old at the time. (Courtesy of the Singleton family.)

Joyce Batson Harris on First Street, Late 1960s. Joyce was also a neighbor of the Singletons and lived on First Street, NW. The brick buildings are well known in Bloomingdale. (Courtesy of the Singleton family.)

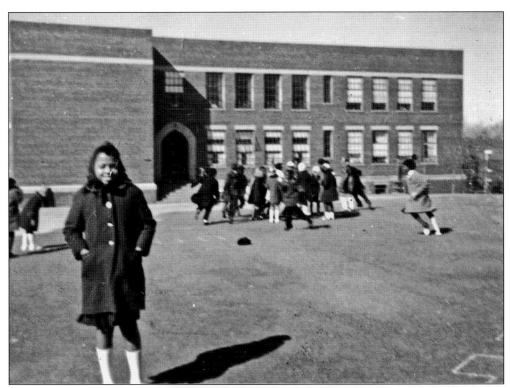

SHEILA MILLER "COOKIE" (NOW DECEASED) OUTSIDE AT ST. MARTIN'S SCHOOL, AROUND 1967. St. Martin's was very proud of its school, which served many families in the Bloomingdale, Edgewood, and Eckington neighborhoods. (Courtesy of the Singleton family.)

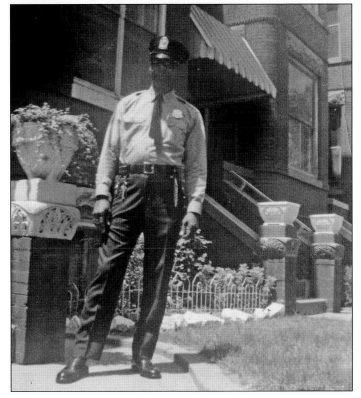

SAMUEL SINGLETON WEARING HIS HOWARD UNIVERSITY UNIFORM. Samuel was very proud of his job at Howard University and all the benefits he received from his job. During this time, people generally worked the same job for 40 or 50 years until they retired. Here Samuel is pictured in front of his First Street home. (Courtesy of the Singleton family.)

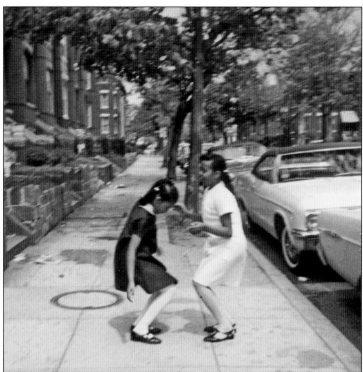

DEBBIE AND DONNA SINGLETON ON FIRST STREET, NW, JUNE 1967. First Street, NW, links many of the neighbors and serves as a prominent street in Washington, D.C. (Courtesy of the Singleton family.)

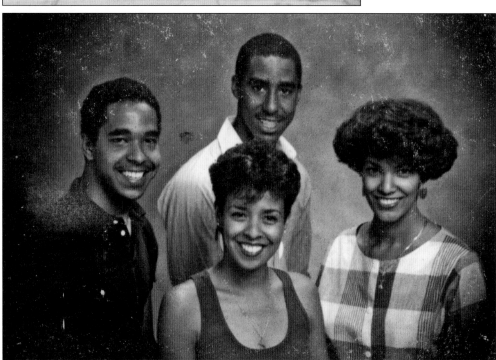

FAMILY PORTRAIT, 1985. Shown here is a rare family photograph with all the siblings together. From left to right are (first row) Debbie Singleton; (second row) Samuel Singleton, Christopher Hayes (their half-brother), and Donna Singleton. (Courtesy of the Singleton family.)

32

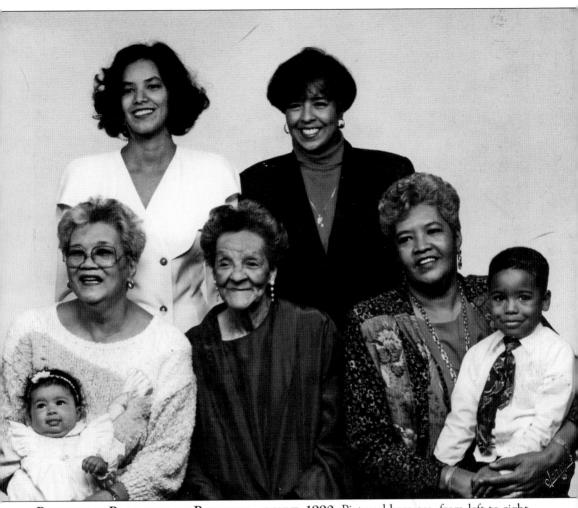

PORTRAIT OF BLOOMINGDALE RESIDENTS, AROUND 1990. Pictured here are, from left to right, (first row) baby Danielle Dunston (17 years old as of 2010) on the lap of Anita Hawkins, Eleanor Singleton, and Devin Kittrell on the lap of Lanita Singleton; (second row) Donna Singleton Dunston and Debbie Singleton. (Courtesy of the Singleton family.)

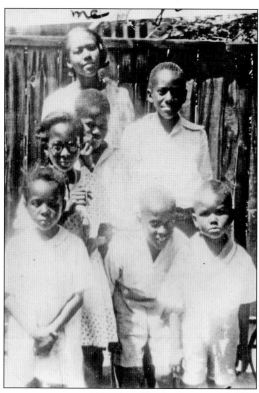

THE SIMONS CHILDREN, AROUND 1931. Pictured from left to right are (first row) Phyllis, Bill, and Kemble; (second row) Ruth, Garrett, and Alfred. Jo is in the back by the fence. (Courtesy of the Simons/Nicholson family.)

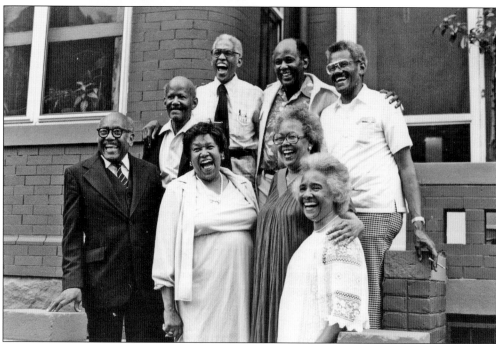

EIGHT BROTHERS AND SISTERS, 1980s. From left to right are (first row) Alfred Simons, Josephine Wade, Ruth Nicholson, and Phyllis Ferguson; (second row) Garrett Simons, Bill Simons, Mills McDaniel "Mack" Simons, and Kemble Simons. (Courtesy of the Simons/Nicholson family.)

ARAM AND HIS GRANDMOTHER, AROUND THE EARLY 1940S. Aram is one of the descendants of the Simons family, Casper (Aram) Garrett Jr. The children were reading one day and a character in the story was named Aram. After that, Casper adopted the name. The children recalled in their journals and biographical information that these town houses only had one bathroom, but they were quite happy to share this space and never had difficulty. (Courtesy of the Simons/ Nicholson family.)

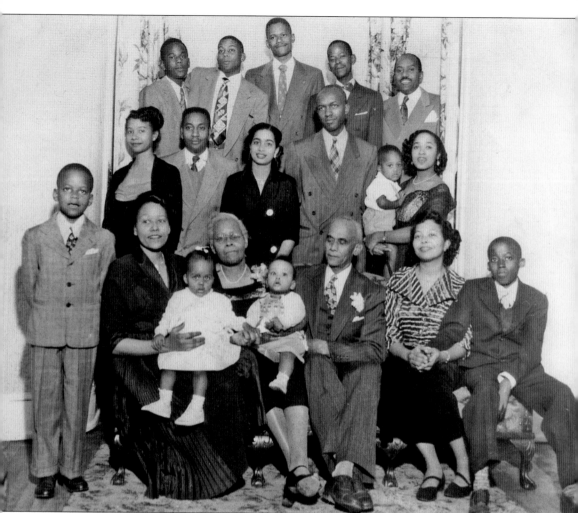

THE SIMONS FAMILY, 1952. The following are, from left to right: (first row) Paul Simons (standing), Josephine Wade, Phyllis Wade (baby), Mattie Simons, David Nicholson, Ruth Nicholson, Casper (Aram) Garrett Jr.; (second row, standing) Phyllis Simons, Roy Nicholson, Elaine Simons, George Wade (dentist), Alfred Simons, III "Skipper" (baby), Marion Simons; (third row, standing) Mills "Mack" Simons, Bill Simons, Kemble Simons, Garrett Simons, and Aldred Simons Jr. (Courtesy of the Simons/Nicholson family).

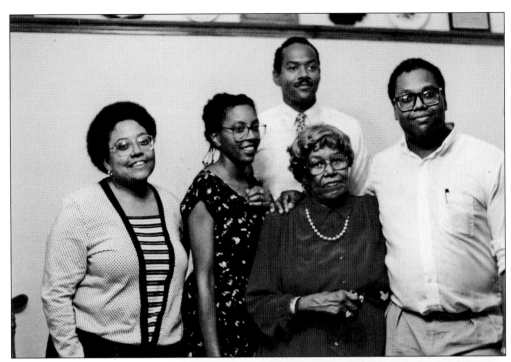

SIMONS DESCENDANTS.
From left to right are Phyllis
Nicholson, another Phyllis
Nicholson, aunt Jo Wade,
and William Nicholson. J.
Myron Simons is in back,
Josephine Nicholson, Jon
Myron Simons, Josephine
Wade, and William
Nicholson. (Courtesy of the
Simons/Nicholson family.)

110 S STREET, NW,
AROUND 1990. This is a
front door in Bloomingdale.
In 1928, the Simons family
moved from 50 L Street,
NW, to 110 S Street, NW.
They began to enjoy indoor
plumbing, electricity, and
a nice home perfect for
their family. The Simons
family was fortunate
enough to keep historic
photographs of their family
for over 70 years, tracking
their time from 1928 to
the present. (Photograph
by Tim Brown.)

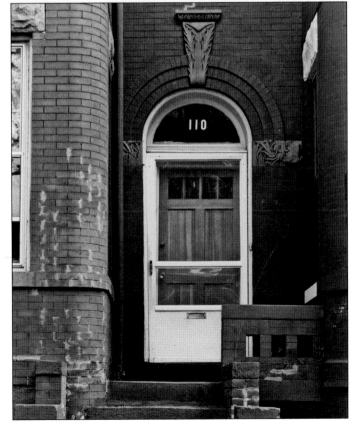

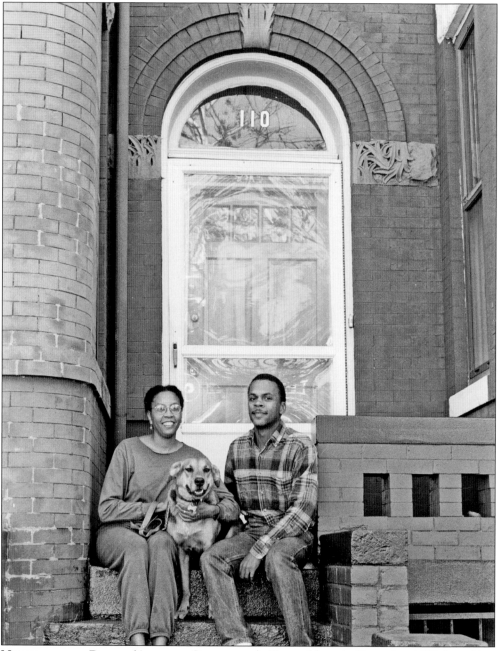

NICHOLSON AND BROWN (ANOTHER GENERATION). Pictured here in December 1998, Josephine Nicholson, Ella the dog, and husband Tim Brown sit outside their front door at 110 S Street. (Courtesy of the Simons/Nicholson family.)

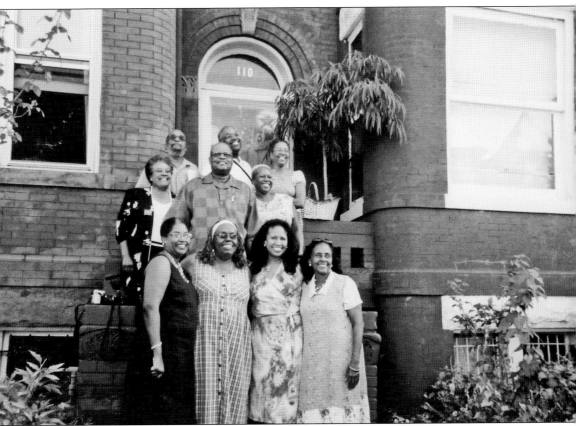

FIRST COUSINS AND SIBLINGS, 2007. Pictured are, from left to right, (first row) Wilma Simons, Phyllis Wade, Jocelyn Ferguson, and Sheryl Simons; (second row) Phyllis Nicholson, Paul Simons, and Kay Ferguson; (third row) David Nicholson, William Nicholson, and Jo Nicholson. (Photograph by Elena Nicholson.)

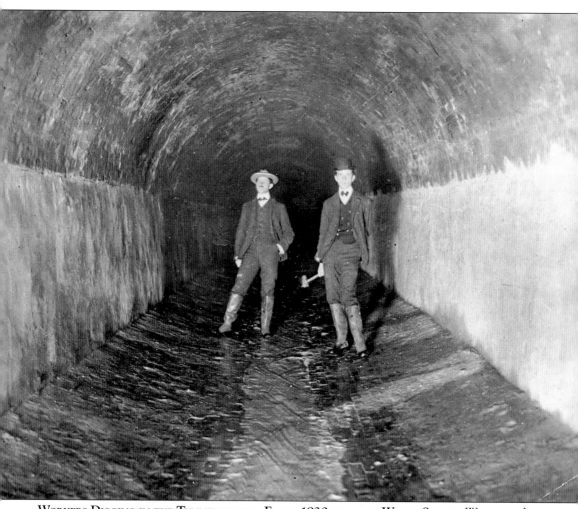

WORKERS DIGGING IN THE TUNNELS IN THE EARLY 1930S FOR THE WATER SUPPLY. Water supply was a major issue in the Washington, D.C., area due to waterborne diseases. Engineers and scientists worked together to create a better, health-conscious plan for acceptable drinking water. (Courtesy of *Star* Collection, Washingtoniana Division, D.C. Public Library.)

Two

MIDDLE YEARS IN BLOOMINGDALE
FROM THE 1960s

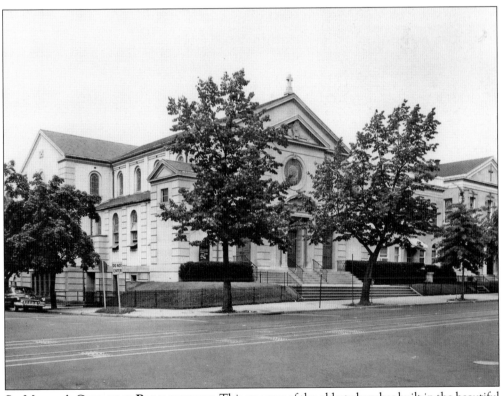

ST. MARTIN'S CHURCH IN BLOOMINGDALE. This was one of the oldest churches built in the beautiful Bloomingdale neighborhood. According to St. Martin's history, the church was built in 1902, with Rev. Eugene Hannon as its founding pastor. At the same time, the parish hall was built, which later became the community center, and the school was quickly begun afterwards. Later additions were built on, including the basement church on North Capitol and T Street, NW. In 1913, some streets in Bloomingdale were built, and in 1939, the main church was added. St. Martin's School served a large number of community residents and parishioners from 1920 to 1990.

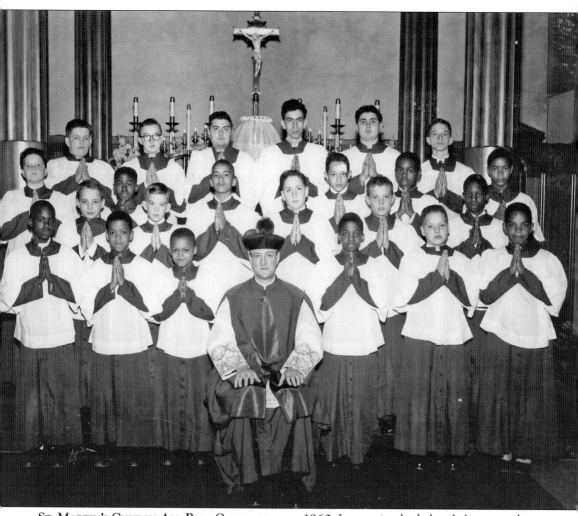

ST. MARTIN'S CHURCH ALL-BOYS CHOIR, AROUND 1960. Integration had already begun at this time. Traditional choir robes were cheerfully used by some members pictured here.

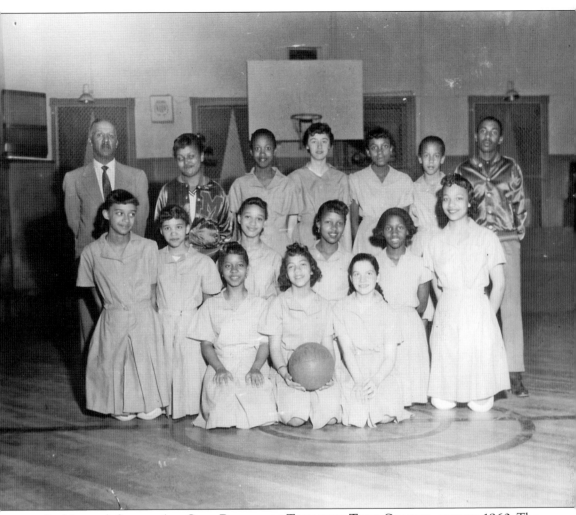

St. Martin's School All-Girls Basketball Team with Their Coaches, around 1960. The girls wore gym dresses rather than the modern-day gym clothes of T-shirts and shorts. Having an all-girls basketball team was quite progressive for its time; however, the staff at St. Martin's Church wanted the school to be successful not only in academics but also in extracurricular activities.

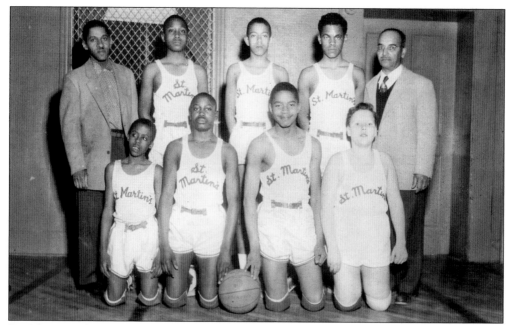

St. Martin's School All-Boys Basketball Team with Coaches. St. Martin's also enjoyed a strong boys basketball team. The team participated in numerous meets and games with other schools in the area.

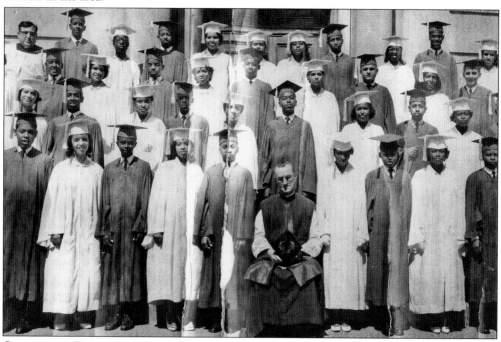

Graduation Day at St. Martin's School with One of the Priests. Graduation was viewed as a very big accomplishment, especially as attending college in the future was not always an option for the children living and attending school in Bloomingdale. Many graduates of high school went on to enjoy full and successful occupations as secretaries, bus drivers, carpenters, and other lucrative blue-collar jobs.

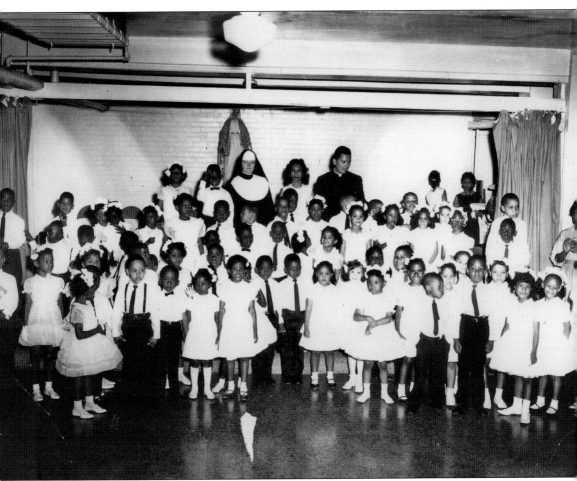

ASSEMBLY FOR ST. MARTIN'S SCHOOL, 1960S. This was for the elementary section at St. Martin's School, and the teachers included a nun and a priest. For many years, the majority of the teaching staff of St. Martin's School was either priests or nuns. The current presiding priest at St. Martin's Church is Fr. Michael J. Kelley.

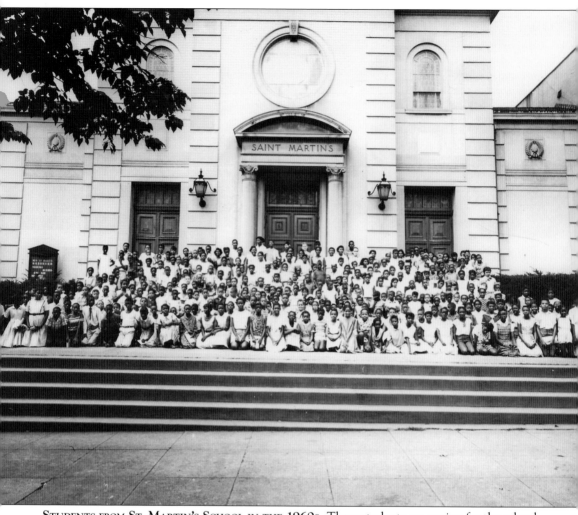

STUDENTS FROM ST. MARTIN'S SCHOOL IN THE 1960s. These students are posing for the school picture at St. Martin's Church on Rhode Island Avenue, NW, in Bloomingdale. (Courtesy of St. Martin's Church archives.)

McMillan Filtration Site. In 1905, the McMillan Sand Filtration Site was finished and was a major health improvement because sand was used to purify water instead of chemicals. The McMillan Sand Filtration Site was purchased by the D.C. government. In 2005, the D.C. Preservation League named the McMillan Sand Filtration Site one of the most endangered places in the district. This site has been the focus of a great deal of controversy. (Courtesy of Washingtoniana Division, D.C. Public Library.)

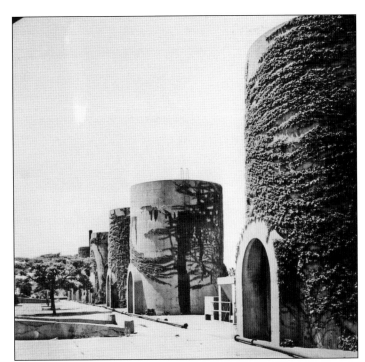

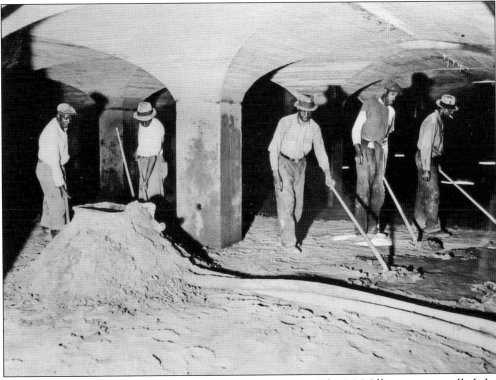

Inside the Tunnel at the McMillan Filtration Site. The McMillan site was called the Washington City Reservoir or the Howard University Reservoir and was completed in 1902 by the Army Corp of Engineers. (Courtesy of Washingtoniana Division, D.C. Public Library.)

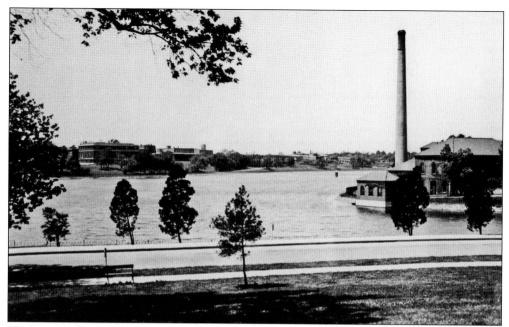

VIEW OF THE RESERVOIR FROM THE McMILLAN FILTRATION SITE. The filtration site was located on top of Smith Spring, which provided drinking water. Although early residents of Washington, D.C., used springs as their source of drinking water, as time went by and the city's population kept growing, the Potomac River became the city's primary source of water, as established by Congress in 1850. (Courtesy of Mary Mitchell, Washingtoniana Division, D.C. Public Library.)

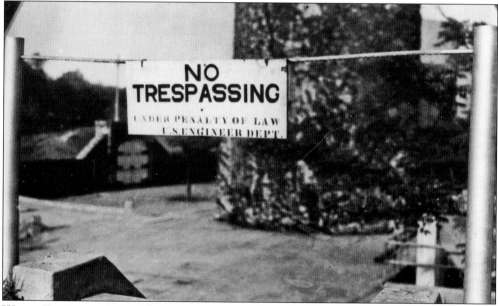

WATER FILTRATION SITE. After a rash of robberies, guards were posted 24 hours a day and signs were put up to keep out vandals. The city of Washington was very conscientious about protecting the water supply. This view inside the pump room at Second and Bryant Streets, NW, by Howard University in Bloomingdale is dated March 16, 1950. (Courtesy of Washingtoniana Division, D.C. Public Library.)

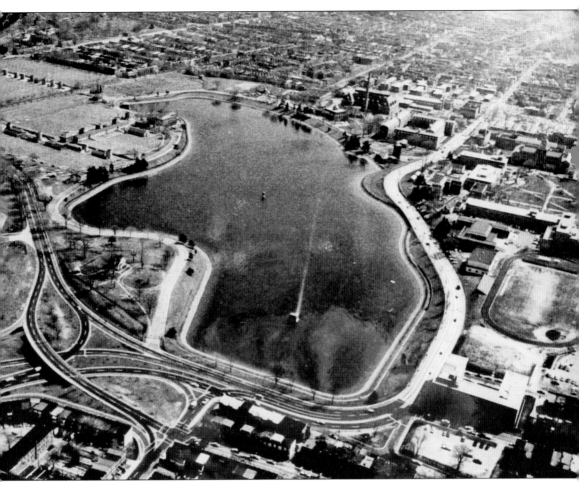

AERIAL PHOTOGRAPH OF THE MCMILLAN RESERVOIR. This picture was taken of the corner of First Street, Michigan Avenue, Channing Street, and North Capitol Street on March 26, 1964. The McMillan Reservoir (sometimes spelled as McMillian) Sand Filtration Site was built in 1905 on 25 acres of land and has houses, sand bins, washers, and huge sand filtration beds that treated the water before dispersing it to the city. During the 80 years of this innovative water system, typhoid epidemics and other waterborne diseases were eliminated. Before the water treatment system at the reservoir, people obtained water from local springs, and in 1808, the first city system piped water using hollowed-out trees buried under the street. After the Potomac River was identified as a water source in 1850, the aqueduct was established, built largely by Lt. Montgomery C. Meigs, who served later as the quartermaster general of the Union army. The aqueduct began operations in 1859. In 1902, the aqueduct could no longer handle the large number of people living in Washington, D.C., and a new system was desperately needed to treat the sediment found in the Potomac River. Construction for the McMillan Reservoir began in 1903. (Courtesy of Washingtoniana Division, D.C. Public Library.)

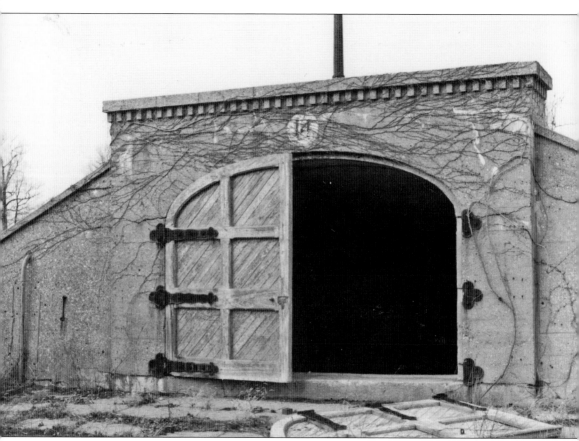

SLOW SAND FILTRATION SITE. The reservoir was later renamed the McMillan Slow Sand Filtration Plant. It had a pumping station that helped bring the water up into the 29 sand filtration beds, a water filtration reservoir of more than 10 million gallons, boilers, and a power plant. The combination of the sand filtration resulted in more than 70 million gallons of water every day, more than enough to serve the city. Here is Vault No. 14. Heavy hinges were used on the structure, and an architectural facing was placed over the arch at the McMillan Sand Filtration Site. (Photograph by Jenifer Simpson, 1989.)

Design of Filtration Site. The design of the water filtration site was done by Lt. Col. Alexander M. Miller. He had already begun to experiment with the purification of water using slow sand and mechanical filters. Here are some steps to electric firing in the McMillan Filtration Site. Electric firing replaced animal labor; in this case, donkeys were used. (Photograph by Jenifer Simpson, 1989.)

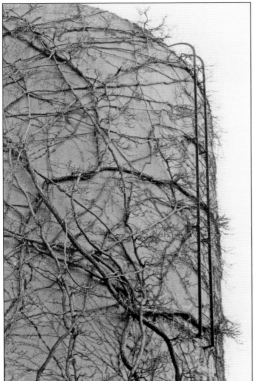

Ivy on the McMillan Filtration Site. In 1905, the reservoir became operational and improved the water quality. There was a decrease of waterborne diseases of more than 90 percent, and the residents reported enjoying clear, clean water. Ivy is pictured here at the McMillan Sand Filtration Site, where the water tanks were covered. The ladder was used by workmen to check water levels. (Photograph by Jenifer Simpson, 1989.)

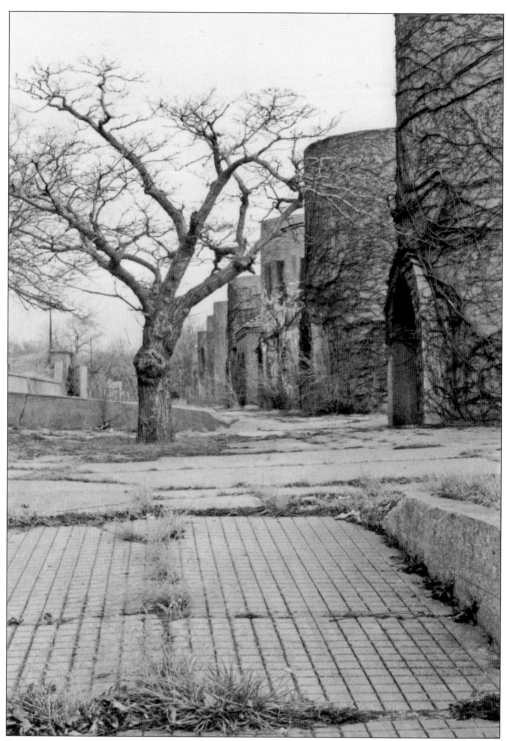

Ramp to the Filtration Site. A brick ramp was built to go up in the McMillan Sand Filtration Site. Donkeys brought in sand and worked in here before the animals were phased out and electric machines were used to lift and move the water. (Photograph by Jenifer Simpson, 1989.)

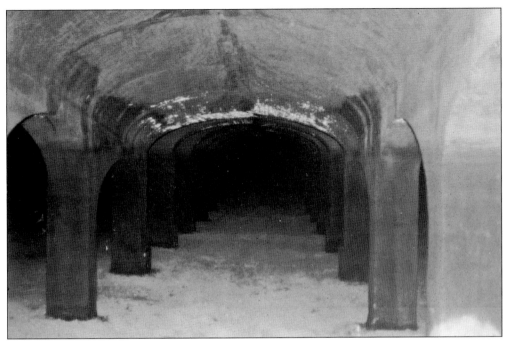

INSIDE ONE OF THE UNDERGROUND VAULTS. This photograph shows columns and sand at the McMillan Sand Filtration Site. (Photograph by Jenifer Simpson, 1989.)

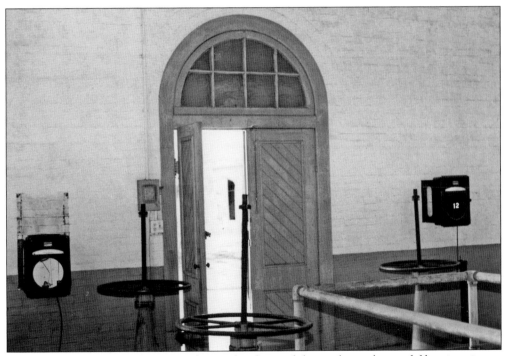

INSIDE THE SAND VAULTS. Here is the inside of one of the vaults at the sand filtration site on Irving and First Streets, NW. On the wall are the meters that measured water. (Photograph by Jenifer Simpson, 1989.)

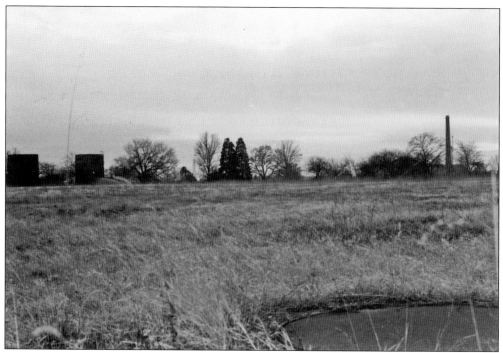

Vault at the McMillan Sand Filtration Site. This photograph shows the ground vault opening at the McMillan Sand Filtration Site. (Photograph by Jenifer Simpson, 1989.)

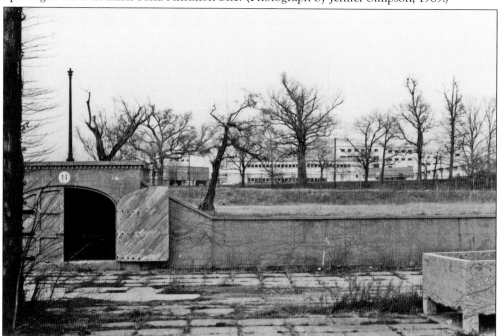

The Veterans Hospital in Washington, D.C. The hospital was located in the rear at the McMillan Sand Filtration Site on Irving Street, NW. The Veterans Affairs Office was opened in 1930 to assist war veterans with benefits and medical treatment. (Photograph by Jenifer Simpson, 1989.)

INSIDE SAND VAULT NO. 18 AT THE McMILLAN SAND FILTRATION SITE. This site spans 25 acres at North Capitol Street and Michigan Avenue, NW, and has been the result of years of discussions and controversy as the city plans what to do with this large area. (Photograph by Jenifer Simpson, 1989.)

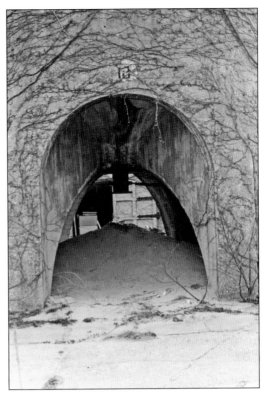

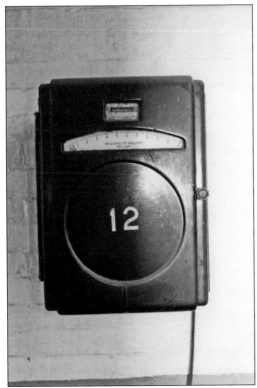

METER MEASURING MILLIONS. Every day, millions of gallons of water are pumped at the McMillan Sand Filtration Site. (Photograph by Jenifer Simpson, 1989.)

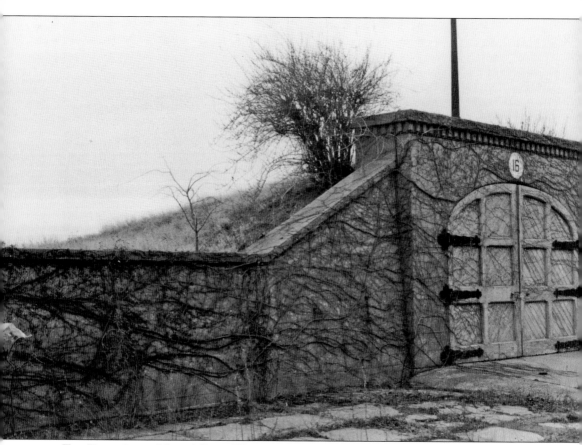

THE DOORWAY TO NO. 16 SAND WATER TANK. Pictured here is the doorway to one of the sand water tanks, which was doorway No. 15. Water was stored in these massive tanks. (Photograph by Jenifer Simpson, 1989.)

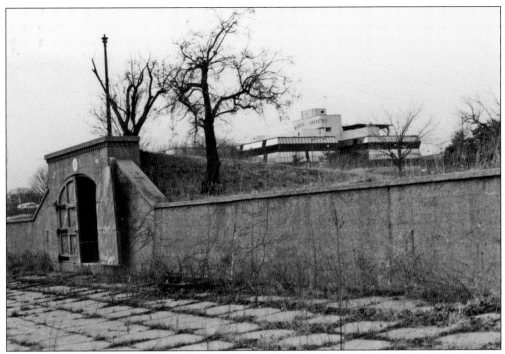

Doorway into Holding Tanks. The Children's Hospital can be seen in background before redevelopment. (Photograph by Jenifer Simpson, 1989.)

View to First Street, NW, in Bloomingdale. This picture was from inside the McMillan Sand Filtration Site. (Photograph by Jenifer Simpson, 1989.)

ANOTHER VIEW OF WATER TOWERS IN THE MCMILLAN SAND FILTRATION SITE. Discussions have ranged from a planned green park and recreation area for the children in the Bloomingdale neighborhood to a small mall with shops like Starbucks, specialty sandwich shops, clothing stores, and a convenience store. (Photograph by Jenifer Simpson, 1989.)

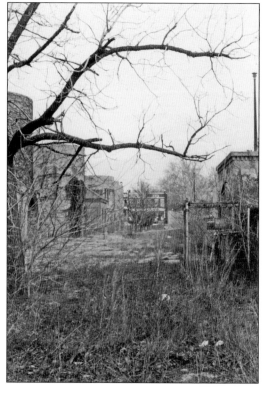

VIEW TOWARDS NORTH CAPITOL STREET, NW, INSIDE MCMILLAN NO. 12. A foundation is being dug in Bloomingdale. Work was constantly done to keep the roads up to date. This photograph was taken at the McMillan Sand Filtration Site. (Photograph by Jenifer Simpson, 1989.)

DIGGING A FOUNDATION ON A STREET IN BLOOMINGDALE. Construction work was being done here in this Bloomingdale neighborhood; often manual digging was done rather than mechanical. (Courtesy of Washingtoniana Division, D.C. Public Library.)

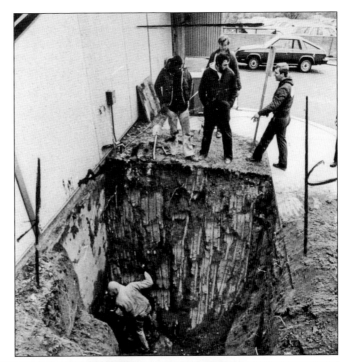

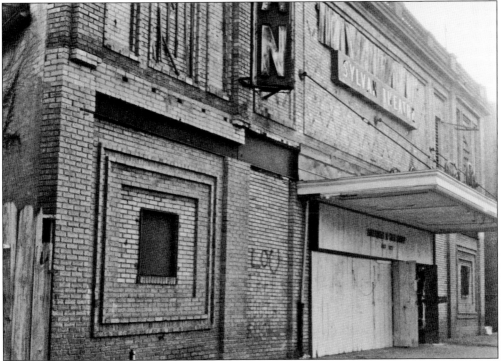

THE OLD SYLVAN THEATRE ON RHODE ISLAND AVENUE, NW, IN BLOOMINGDALE. Several residents remember coming to the theater as children after and during church to watch a good movie. These residents are now in their mid- to late 50s and older. The theater was also used as a furniture store in 1986–1987. (Photograph by Jenifer Simpson, 1986.)

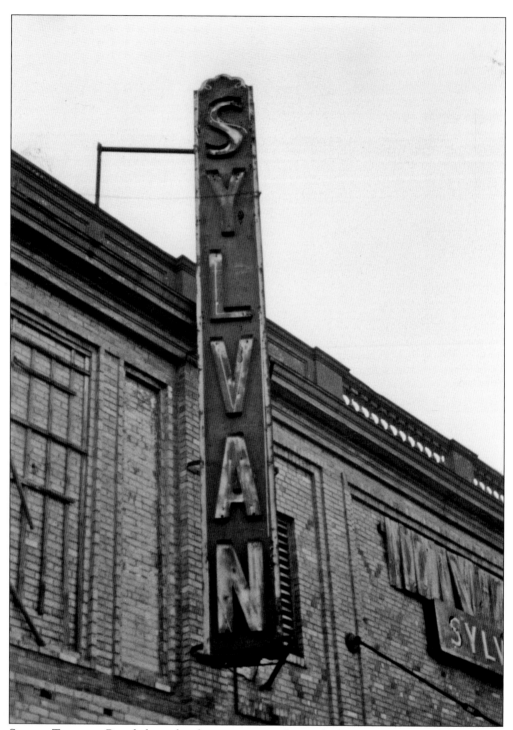

SYLVAN THEATRE. Boarded up, the theater is pictured years before renovation work began and the new TNT Laundromat was installed. Residents stated that movies used to cost 5¢, and that made it very affordable for teenagers and children in the neighborhood. (Photograph by Jenifer Simpson, 1988.)

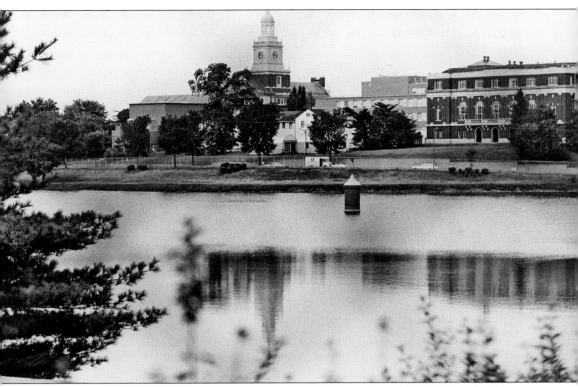

HOWARD UNIVERSITY. Here is picturesque Howard University around 1940. The school was originally a seminary school in the mid-1800s. However, it expanded and became a prestigious university. (Courtesy of Washingtoniana Division, D.C. Public Library.)

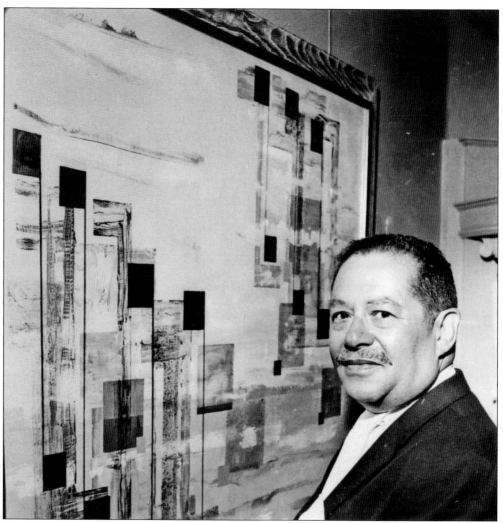

ALONZO ADEN (1906–1961) AT 127 RANDOLPH STREET, NW, IN BLOOMINGDALE. Aden was one of the founders of the Barnett Aden Gallery along with James Vernon Herring. This gallery was the first privately owned black gallery in Washington, D.C. (Courtesy of Washingtoniana Division, D.C. Public Library.)

HOWARD UNIVERSITY TRAINING TOWER. This tower is near Howard University and McMillan Reservoir. (Courtesy of Washingtoniana Division, D.C. Public Library.)

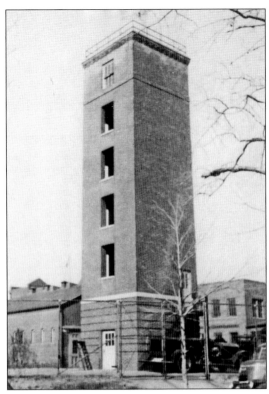

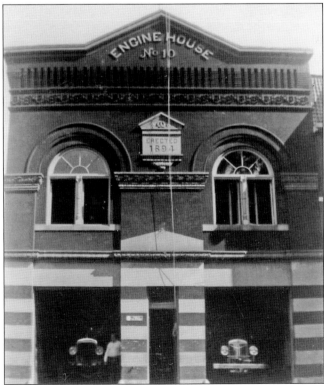

FIRE STATION IN BLOOMINGDALE, 1945. This fire station was located on North Capitol Street, and there is discussion about renovating it. (Courtesy of Washingtoniana Division, D.C. Public Library.)

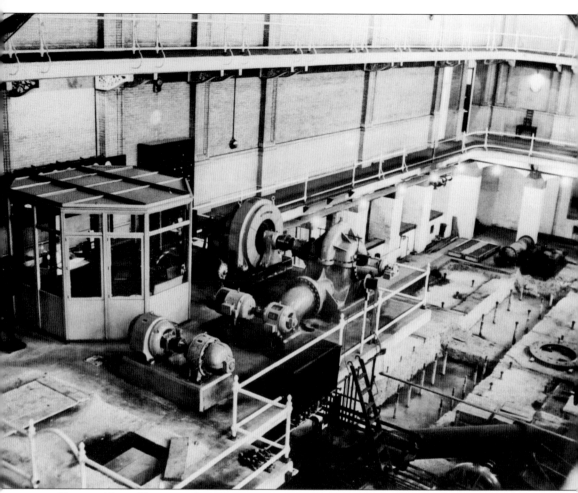

VIEW OF PUMP ROOM AT SECOND AND BRYANT STREETS, NW, MARCH 16, 1950. This water system provided water to various areas in Washington, D.C. (Courtesy of Washingtoniana Division, D.C. Public Library.)

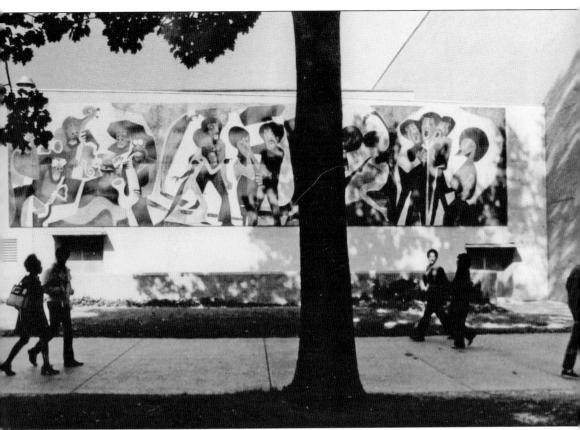

HOWARD UNIVERSITY MURAL, 1977. Howard University's close proximity to Bloomingdale created a natural flow between the two communities. Howard University students have lived in the adjoining neighborhoods of Bloomingdale, Shaw, and LeDroit Park for years. After students graduated from Howard University, many chose to settle in the Bloomingdale neighborhood, and a large number of artists, musicians, teachers, and lecturers continue to do so today. (Courtesy of Washingtoniana Division, D.C. Public Library.)

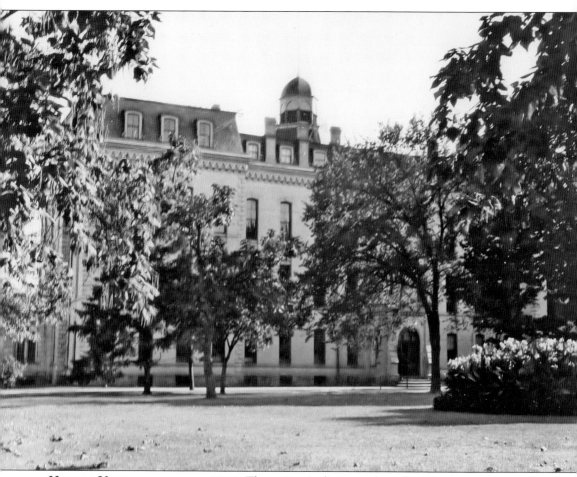

HOWARD UNIVERSITY, AROUND 1940. The university began with a school for African American clergy in 1866, shortly after the Civil War. However, two years later, it included additional departments and blossomed into a full-fledged university. This library is a historical landmark in Washington, D.C. Dedicated in 1939, the library has been used in pictures and posters depicting D.C. for a number of years. Albert Cassell was the architect who designed the building. (Courtesy of Washingtoniana Division, D.C. Public Library.)

Three

Latter Years in Bloomingdale
From the 1970s

Johnson Family. Children, grandchildren, and neighbors of Mrs. Johnson enjoy the neighborhood of Bloomingdale. Mrs. Johnson has been a resident of Bloomingdale for over 30 years. She raised nine children and countless grandchildren and great-grandchildren and took care of many children in the Bloomingdale neighborhood.

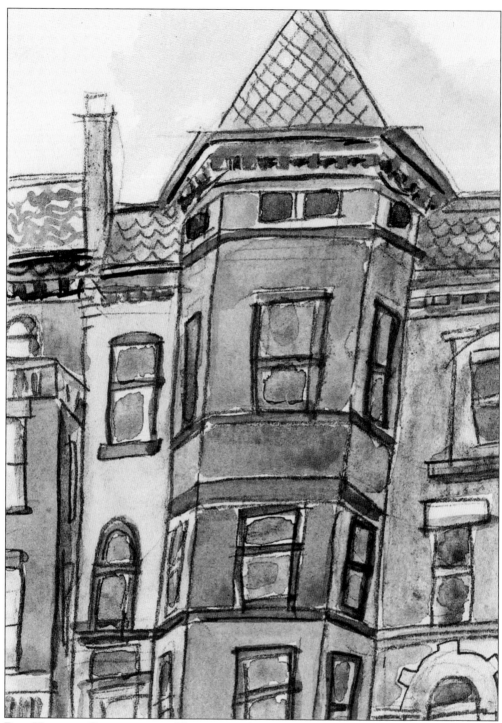

Row Houses in Bloomingdale. The artist is a local Bloomingdale resident and realtor who has lived in the neighborhood for many years. She sketched this classic picture of the row houses in Bloomingdale. (Sketch by Suzanne Des Marais.)

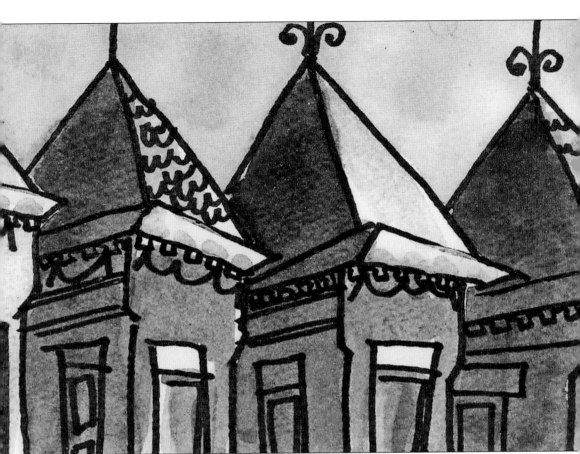

ROOF PEAKS OF BLOOMINGDALE ROW HOUSES. The sketch shows the incredible and intrinsic roof peaks. Many of these homes were designed by a group of architects and designers like Harry Wardman. (Sketch by Suzanne Des Marais.)

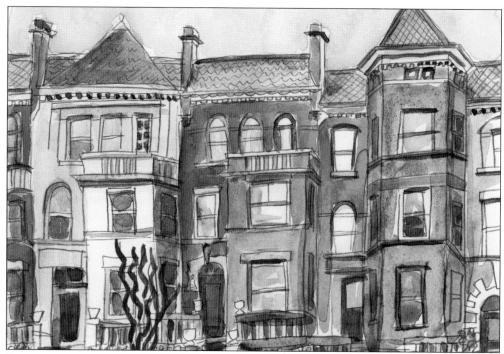

BLOOMINGDALE ROW HOUSES. This sketch shows the row houses typical of Bloomingdale. Suzanne Des Marais states that when drawing her sketches, she simply visualizes the homes in the area and doesn't sketch a specific group of homes. (Sketch by Suzanne Des Marais.)

FIRST STREET, NW, IN BLOOMINGDALE. This street has become a major thoroughfare in Bloomingdale, as it links the rest of the city to three prominent hospitals: Children's Hospital, Washington Hospital Center, and Veterans Hospital, all on First Street, NW. Some of the hospitals have helicopter pads on their roofs to fly in critically injured patients. (Photograph by Rosemarie Onwukwe, 2008.)

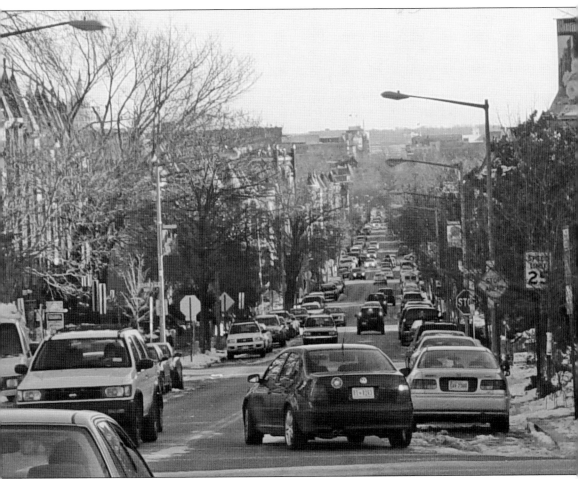

FIRST STREET TRAFFIC IN BLOOMINGDALE. This picture shows the changing traffic patterns during rush hour. There are hundreds of staff members who work in the nearby hospitals, and many have decided to live in the Bloomingdale neighborhood, making their access to work a little easier. (Photograph by Rosemarie Onwukwe, 2008.)

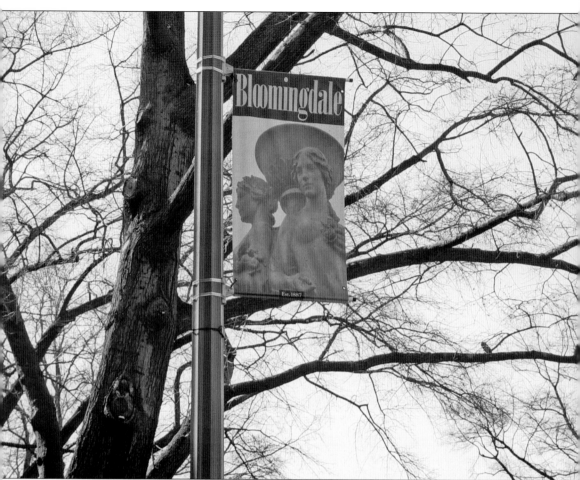

BLOOMINGDALE SIGNAGE. The Bloomingdale banners were a beautiful addition to the neighborhood and were part of a streetscape improvement project. The funding for these banners was from a neighborhood investment grant designed to help beautify the neighborhood. This grant was submitted by the former ANC5Co3 commissioner Tom Fulton around 2006. Later on, Stuart Davenport became commissioner and monitored the grant. Included in the grant were design and creation of tree boxes along parts of North Capitol Street, Rhode Island Avenue, and parts of First Street from Rhode Island Avenue to Florida Avenue, NW. (Photograph by Rosemarie Onwukwe, 2008.)

SIGN IN BLOOMINGDALE. The banners were created to help delineate the Bloomingdale neighborhood for other people from outside areas. They were designed to improve neighborhood pride and help the residents reclaim part of the neighborhood. (Photograph by Rosemarie Onwukwe, 2008.)

NOA GALLERY IN BLOOMINGDALE. This gallery, a prominent fixture in the neighborhood, receives clients via appointment only for now. Residents argue as to whether the gallery is in Bloomingdale or LeDroit Park, a common cause of friendly disagreements between the two neighborhoods. What makes it even more confusing are areas that used to be in Bloomingdale but with reorganizing of districts have now become part of Le Droit Park. (Photograph by Rosemarie Onwukwe, 2009.)

ART GALLERY IN BLOOMINGDALE ON RHODE ISLAND AVENUE, NW. The gallery has a beautiful sculpture. This is a pleasant eye-catching piece that all the neighbors enjoy. (Photograph by Rosemarie Onwukwe, 2009.)

NOA GALLERY. The gallery is owned by Michael Little, a Bloomingdale/Le Droit Park resident who has lived in the neighborhood for many years. He remembers how wide Rhode Island was before the government widened the roads. Everyone's yard was reduced to much smaller lots; still, he stated that people took a great deal of pride in their little yards and worked hard to have a beautiful garden. (Photograph by Rosemarie Onwukwe, 2009.)

INTERIOR OF NOA GALLERY. Michael Little enjoyed the neighborhood, especially the TNT Theatre, which was very popular with the residents of Bloomingdale and Le Droit Park and Howard University students. He stated that many affluent people moved into Bloomingdale to have close proximity with Howard University. (Photograph by Rosemarie Onwukwe, 2009.)

RHODE ISLAND AVENUE. In the early 1900s, this road was used by horses and buggies, and the wide road was needed for carriages. The dividing line did not exist then but was erected many years later, after the road was widened. (Photograph by Rosemarie Onwukwe, 2009.)

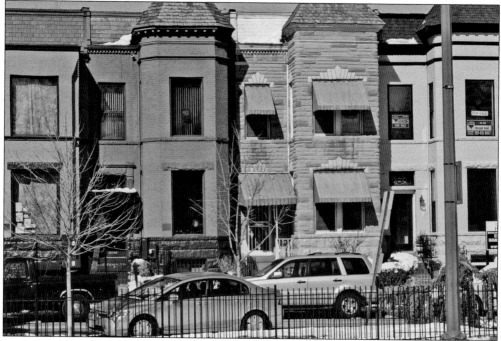

HOUSES ON RHODE ISLAND AVENUE. Even though a great deal of renovations have been done on this portion of Rhode Island Avenue, the basic structures of the homes, some of them over 100 years old, have been maintained. (Photograph by Rosemarie Onwukwe, 2009.)

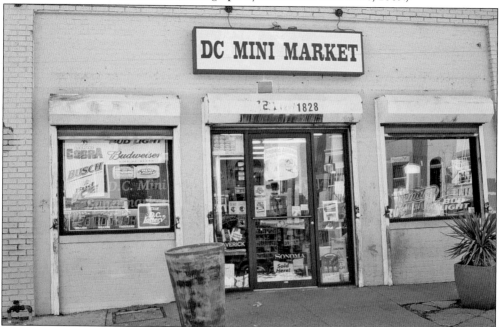

D.C. MINI MART ON FIRST STREET, NW. This store provides snacks and essentials for many neighborhood residents and has proven especially helpful during snowstorms and severe weather conditions. Although the store itself has gone through several owners over the years, it has stayed open. (Photograph by Rosemarie Onwukwe, 2009.)

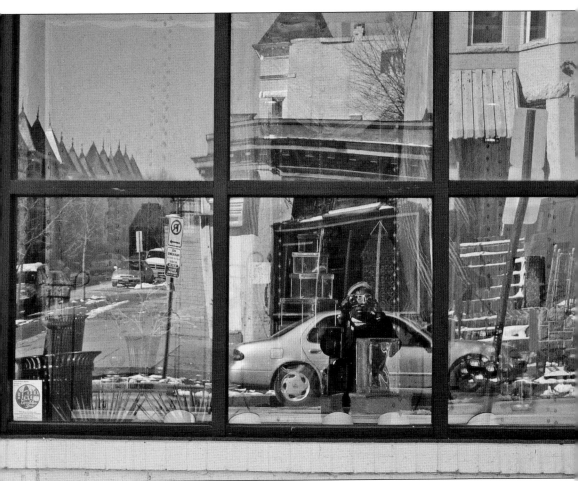

STREETSCAPE PHOTOGRAPH IN BLOOMINGDALE, 2009. The photographer took a picture of one of the display windows on First Street, NW, and got the reflection of the surrounding neighborhood. (Photograph by Rosemarie Onwukwe.)

Big Bear Cafe and the Bloomingdale Farmers Market. Big Bear Cafe is owned by husband and wife Lana Labermeier and Stuart Davenport and since June 2007 has become a fond staple in Bloomingdale. Big Bear is known for its good coffee and relaxed atmosphere and also sells sandwiches, salads, and deserts. The farmers market is held during the spring, summer, and fall and has quite a large following. In more recent years, the farmers market has attracted additional interest from the residents due to its promotion of fresh fruits and vegetables and more organic options than the regular grocery store.

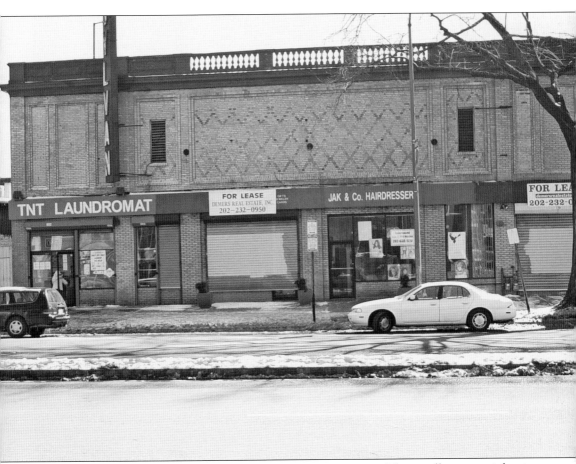

RHODE ISLAND AVENUE, NW, IN BLOOMINGDALE, AROUND 1988. This small commercial strip is still changing. There has been talk of a new store coming to the area as soon as 2011. The TNT Laundromat is used by the locals, and Jaks Hairdresser has been in the neighborhood for decades. (Courtesy Jenifer Simpson.)

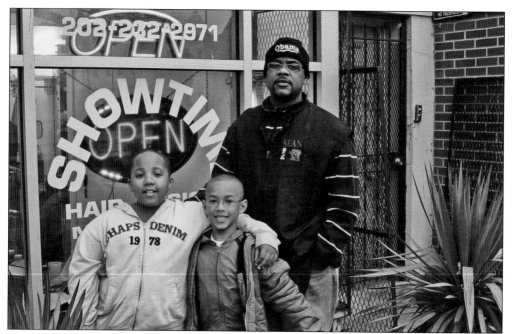

OWNER OF SHOWTIME BARBERSHOP. Owner Sean Wiggins and two young customers, Delester and Miles, are pictured. A previous barbershop was in this same location for a number of years. Longtime residents state that this shop has passed from one owner to the next but stayed primarily as a barbershop. (Photograph by Rosemarie Onwukwe, 2009.)

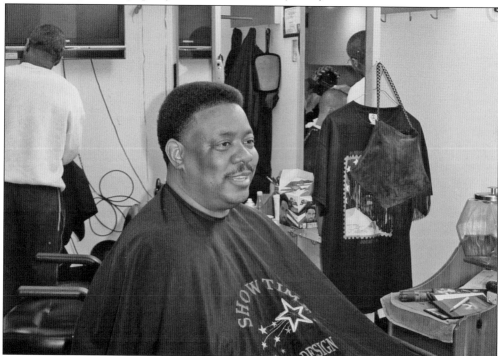

G. BUTTS SPORTS A NEW HAIRCUT. Butts has been a customer for a number of years and enjoys coming to the barbershop on a regular basis. (Photograph by Rosemarie Onwukwe, 2009.)

CAMERON—PART-TIME WORKER, FULL-TIME STUDENT. Cameron, the shop technician, cleans up. Cameron said that he was looking for a part-time job and was able to snag one at the Showtime. He is very interested in how the barbershop works. (Photograph by Rosemarie Onwukwe, 2009.)

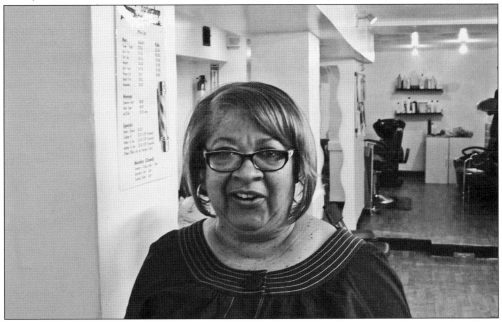

CUSTOMER RENEE EDWARDS. Renee, visiting from out of town, gets her hair done at Showtime, as it serves as both a barbershop and a small hairdressing salon. (Photograph by Rosemarie Onwukwe, 2009.)

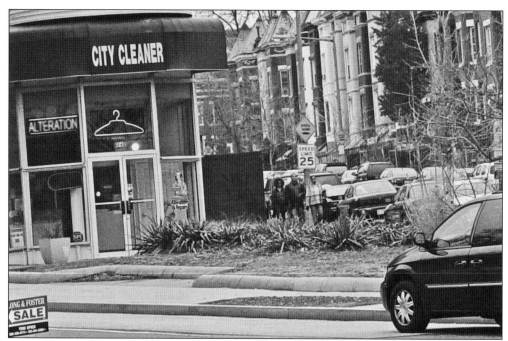

THE LOCAL DRY CLEANER IN BLOOMINGDALE. A previous dry cleaner was also in this location at the corner of Rhode Island Avenue and First Street, NW. The metro bus line has a stop right in front of the dry cleaners, making easy access for all angles. (Photograph by Rosemarie Onwukwe, 2009.)

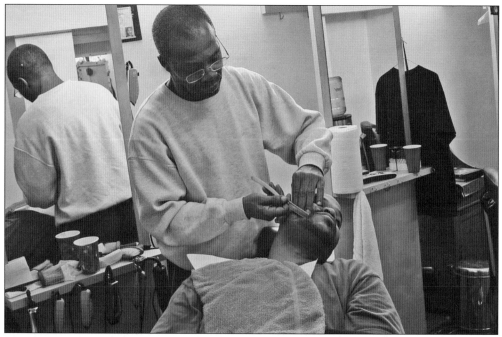

BEN SMALLS GIVES A SHAVE. One of the barbers, Ben Smalls, gives his customer a shave at Showtime Barbershop. Ben has been cutting hair for over 40 years and had previously worked at Seventh and O Streets, NW. (Photograph by Rosemarie Onwukwe, 2009.)

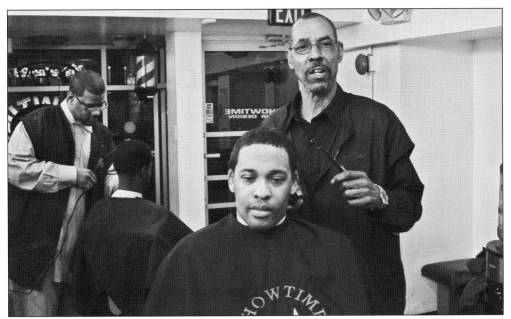

THE POPULAR BARBERSHOP IN BLOOMINGDALE. Rudy Meroex finalizes a customer's haircut. The barbers like to keep up with the trends and styles that the young people like. (Photograph by Rosemarie Onwukwe.)

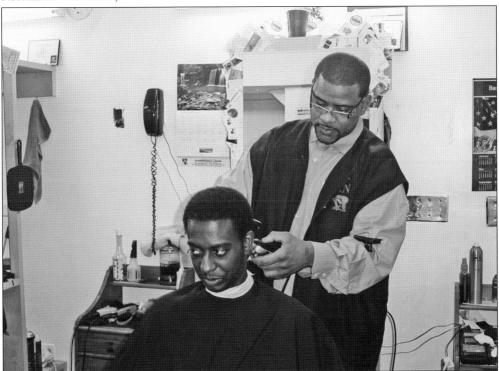

SEAN WIGGENS GIVES A CUSTOMER A HAIRCUT. Wiggens said that when he first opened his barbershop, he would stand outside at the bus stop and hand out fliers offering promotions to try and draw customers into his shop.

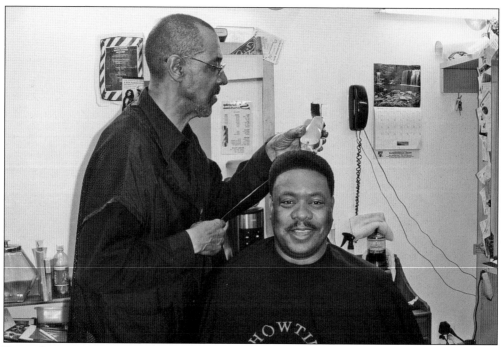

RUDY GIVES A CUSTOMER A HAIRCUT. Rudy has been a barber for many years and enjoys the friendships he has made over the years. The barbershop is like a family. It has regular customers who come by the shop and spend time talking about things going on in the city. Some customers bring crates of soft drinks and sodas to share with others.

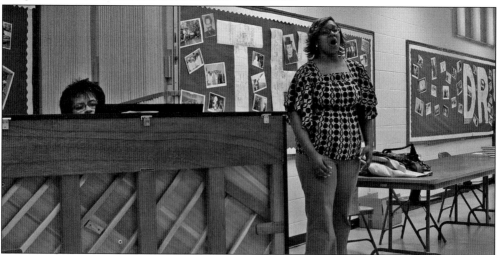

DIMERY MOWERY, YOUNG OPERA SINGER. Dimery, an accomplished teen opera singer, performs at Bloomingdale's Black History Month program at St. George's Episcopal Church. The residents of Bloomingdale put together a brief program honoring several of their own and focused on their talents. Dimery has been studying music for seven years. Most of her training was done with Lisa Eden and Anamer Castrello at Suitland High School Visual and Performing Arts Center under the direction of Kenneth Boucher. Dimery's role models are Renee Fleming, Sumi Jo, Marian Anderson, Denyce Graves, and her mother. Dimery is currently studying opera at the New England Conservatory of Music in Boston. (Photograph by Rosemarie Onwukwe, February 2009.)

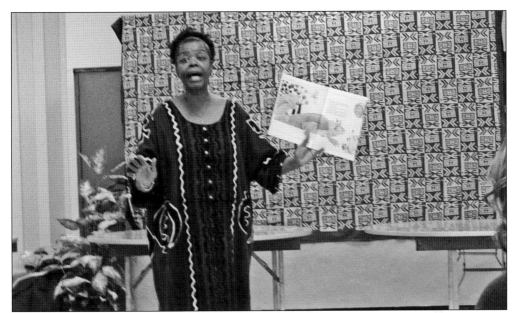

JENNIFER ASHBURN, AFRICAN STORYTELLER, FEBRUARY 2009. Jennifer tells a story at Bloomingdale's Black History Month program at St. George's Episcopal Church. Jennifer, a retired teacher, has been telling stories to her students for 34 years.

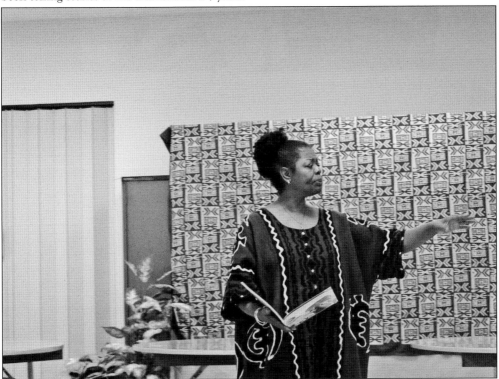

JENNIFER ASHBURN, AFRICAN STORYTELLER, IN BLOOMINGDALE, FEBRUARY 2009. Jennifer is a minister at the Faith and Hope Holiness Church in Washington, D.C. and the Second Baptist Church in Sandusky, Ohio.

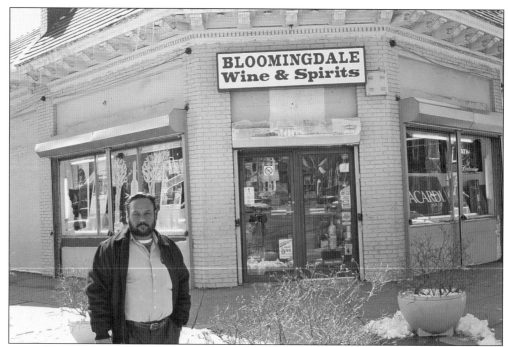

OWNER OF BLOOMINGDALE LIQUOR STORE. The corner of Rhode Island and First Streets, NW, is a common location for meeting. The store also has snacks. Windows Café (not pictured) is another friendly location providing drinks, snacks, and small amenities to the neighborhood of Bloomingdale. The friendly staff and convenient location across the street from the Rhode Island Baptist Church makes it another favorite meeting place for residents.

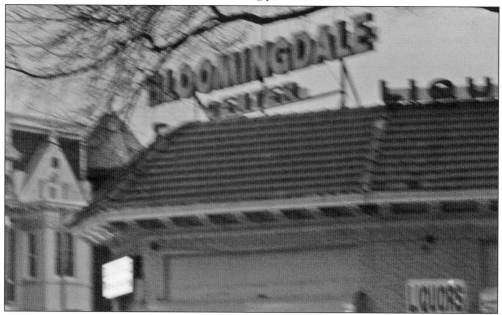

FAMOUS BLOOMINGDALE SIGN ON TOP OF BLOOMINGDALE LIQUOR STORE. The Bloomingdale sign has become a neighborhood landmark. Residents state that a local pharmacy used to be in the location of the current liquor store.

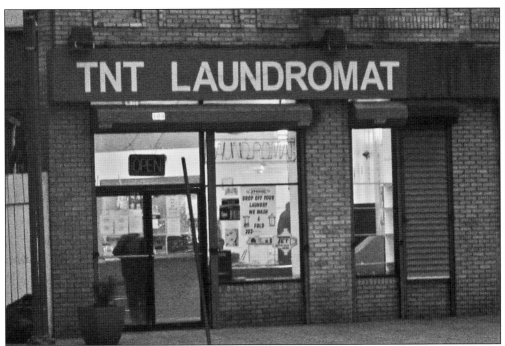

OLD SYLVAN THEATRE. Formally the Sylvan Theatre, this strip has been renovated and now houses a Laundromat, a small specialty shop, and a beauty parlor called Jacks that residents have been patronizing for the past 20 years.

NAZARENE CHURCH ON RHODE ISLAND AVENUE, NW. Longtime residents state that Nazarene church was a nightclub called the Bucket of Blood many years ago.

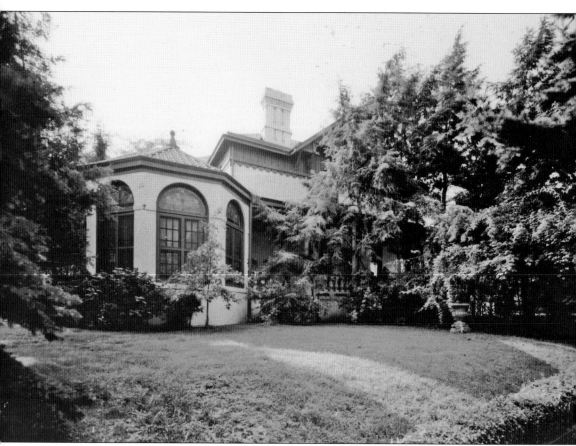

THE ANNA COOPER HOUSE. The famous Anna Cooper lived 106 years, saw the end of slavery, and was the fourth African American woman to receive a doctorate degree. The current owners, Brian Brown and his wife, Louise, have been restoring the Anna Cooper house so that it will look like the original structure in the early 1900s as featured on WETA.

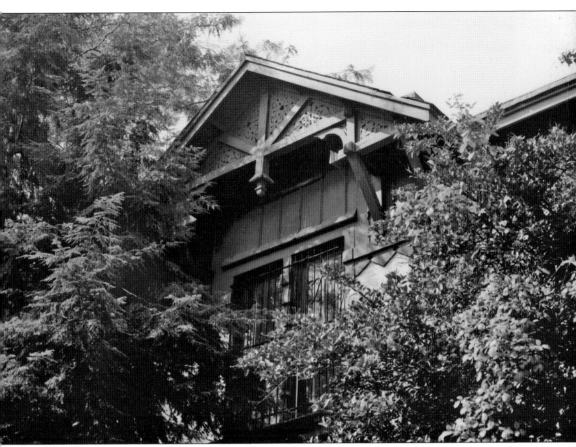

ANOTHER VIEW OF THE ANNA COOPER HOUSE. This picture shows the historic and intricate details of the building structure. Neighbors argue that this home is in LeDroit Park, while residents of Bloomingdale claim this historic home as their own.

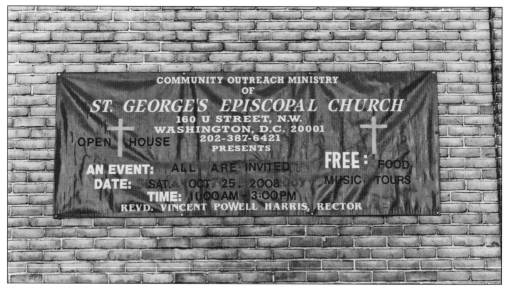

ST. GEORGE'S EPISCOPAL CHURCH'S BANNER. St. George's was proud to display its banner when renovations that took over a decade were done. St. George's is the last historical black church in the Diocese of Washington, D.C. It first began in October 29, 1929, at 85 R Street, NW. Smaller churches, like St. Michael's in Charlottesville, St. John's Episcopal Church, and St. George's in Tenleytown, were all part of the core group that started St. George's. (Courtesy of St. George's Church.)

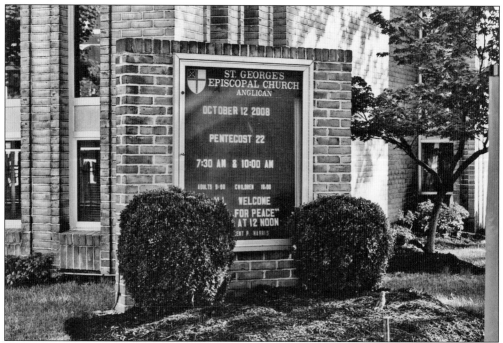

ST. GEORGE'S CHURCH IN BLOOMINGDALE. St. George's has kept its doors open to the public and parishioners since the early 1930s. It survived the Great Depression and continues to have a small but faithful following of members who often commute from as far as Northern Virginia to come in for service on Sunday morning. (Courtesy of St. George's Church, September 2009.)

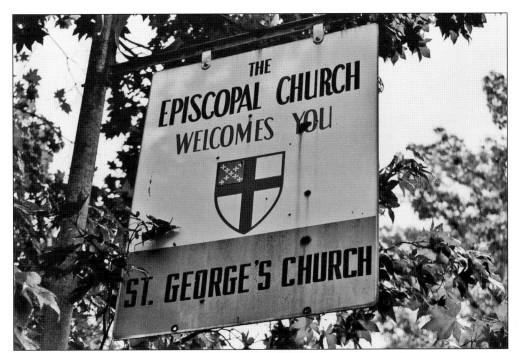

St. George's Signage. The rector since 1991, Rev. Vincent Powell Harris has been a longtime fixture in Bloomingdale, opening the doors of his parish to residents for worship and his community rooms for countless neighborhood meetings, programs, and other events. (Courtesy of St. George's Church.)

Bloomingdale Trees and Gardens. Old-time neighbors claim that when the blooms were full their fragrance was smelled for miles in the Bloomingdale area. The southern magnolia tree graced the yard. (Photograph by Jenifer Simpson, 1993.)

JOSHUA CHARIENITZ, 22 YEARS OLD IN 2010. Joshua, born with cerebral palsy and epilepsy, enjoys the weather in Bloomingdale. Joshua has always been a beloved member of the Bloomingdale community since 1986. (Photograph by Jenifer Simpson, 1993.)

CRYSTAL, CHARLENA, AND DIANE BARNES. Shown here are Crystal, 13, Charlena, 10, and mother Diane Barnes. The family moved to Bloomingdale in June 1974. Diane Barnes lived on Seaton Place in the late 1960s. This picture was taken at Easter, 1987 by James Barnes (now deceased).

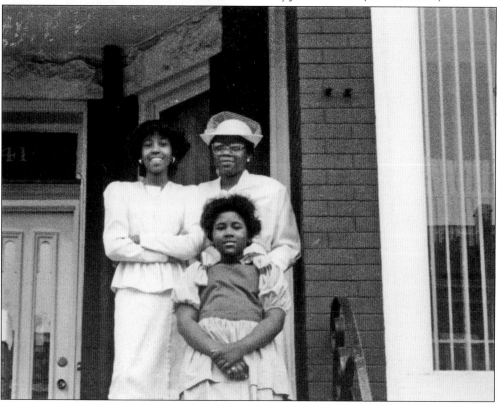

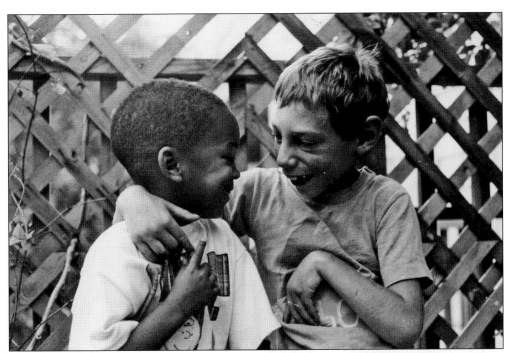

DAVID AND JOSHUA 1992. Best friends share a private joke. The boys enjoyed many wonderful spring, summer, and fall days playing outside with toys, books, games, and a wading pool. (Photograph by Jenifer Simpson.)

CRYSTAL BARNES, 17, READY FOR THE PROM IN BLOOMINGDALE. She graduated from Dunbar High School in 1992. Crystal drove to the prom in a white Z24 and met up with her girlfriends.

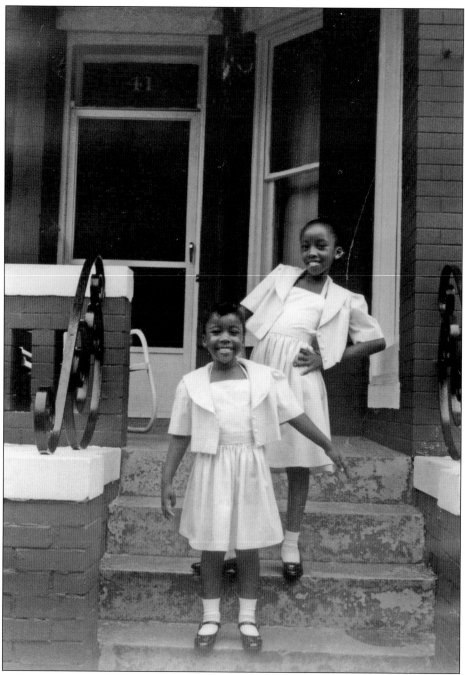

CHARLENA AND CRYSTAL BARNES. Charlena, 7, and Crystal, 10, are pictured after church in 1983. The girls went to K. C. Lewis, Shaw Junior High School, and Dunbar High School. Crystal served as a flag girl and was in the electrical engineering program at Dunbar High School. Both girls were in the honor society, and Charlena was in the mechanical engineering honors society at Dunbar. Crystal attended the University of Maryland–Eastern Shore and then transferred to Howard University, while Charlena attended Pittsburg and transferred to Howard University. Charlena got her master's at the University of Maryland–College Park. (Photograph by Diane Barnes.)

JOSHUA AT AGE 10 AND MOTHER JENIFER SIMPSON IN 1996. Jenifer is a member of the Bloomingdale Civic Association and the Bloomingdale Garden Club and has been an active member in many local and neighborhood associations.

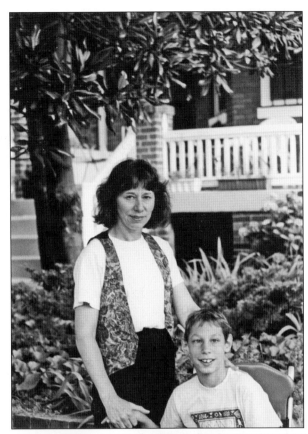

JOSHUA AND DEJUAN. Joshua and DeJuan, both five, are having fun doing some artwork on a nice summer day in 1990. DeJuan is currently attending culinary school in D.C. and is training to be a chef. Joshua is a packing specialist in Pennsylvania. (Photograph by Jenifer Simpson.)

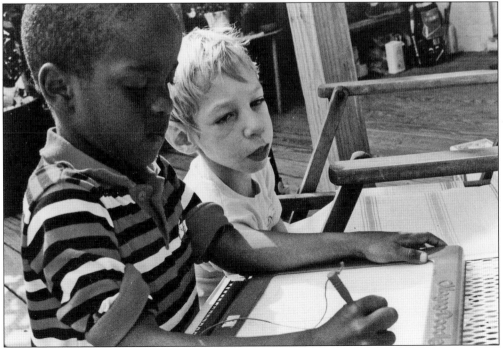

BLOOMINGDALE HOME WITH BEAUTIFUL GARDEN AND SOUTHERN MAGNOLIA TREE, 1995. Although the residents of Bloomingdale only have small front lawns, they pride themselves on keeping their gardens as beautiful as possible. As a result, beautiful flowering plants and their fragrant smells made the neighborhood well known. Longtime residents mentioned that the neighborhood was called Bloomingdale for its beautiful blooming flowers.

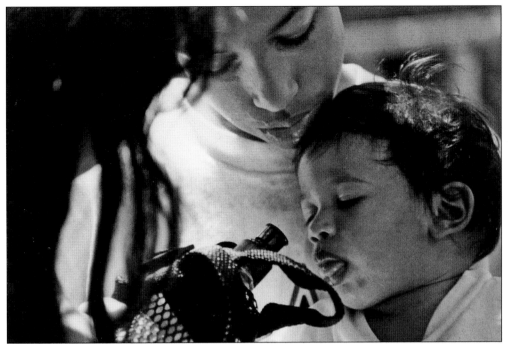

BEATRIZ DURAN (10) AND GERONIMO CHARLES (12 MONTHS). Beatriz and Geronimo are the grandchildren of the Charles family, who have lived in the Bloomingdale neighborhood for over 50 years. Beatriz is now working with the U.S. Air Force as a recruiter. (Photograph by Jenifer Simpson, 1996.)

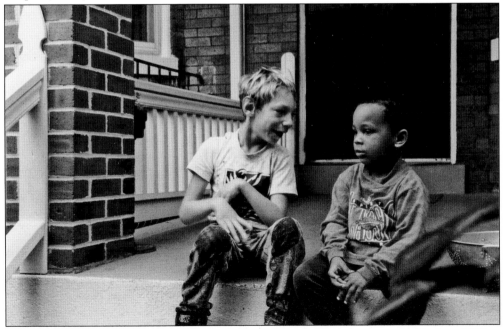

JOSHUA AND DAVID ONWUKWE IN BLOOMINGDALE. The two boys were inseparable from 1992 to 1994 and spent most waking hours together. They swam, played games, went on walks, and met with the other neighborhood children. (Photograph by Jenifer Simpson.)

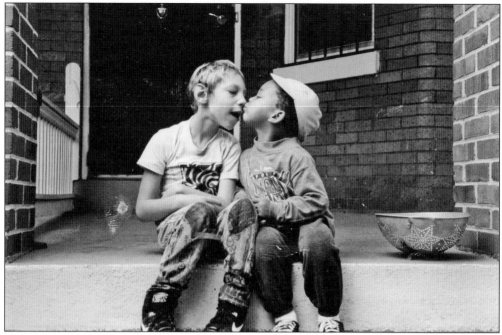

JOSHUA AND DAVID IN BLOOMINGDALE, 1992. Two friends enjoy a day in Bloomingdale. (Photograph by Jenifer Simpson.)

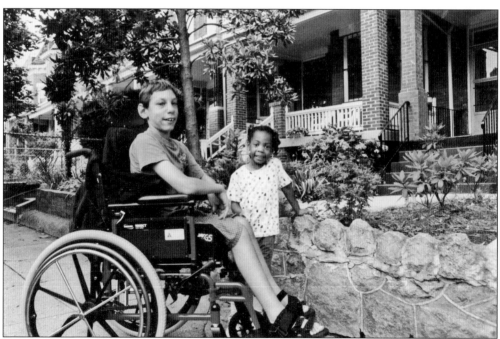

JOSHUA (12) AND NNENNA (5). Nnenna is the sister of David. Notice the stonework in the garden; these stone walls are often found in Bloomingdale. (Photograph by Jenifer Simpson, 1998.)

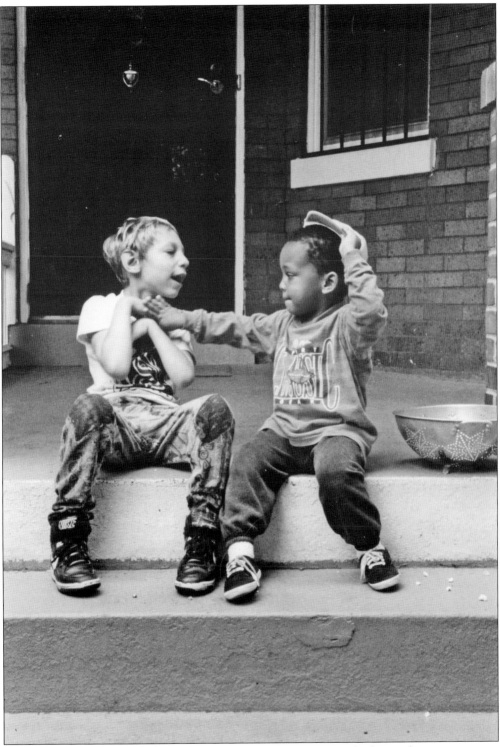

DAVID AND JOSHUA, 1992. The boys enjoyed spending time outside during the warm summer days and also during the fall weather. (Photograph by Jenifer Simpson.)

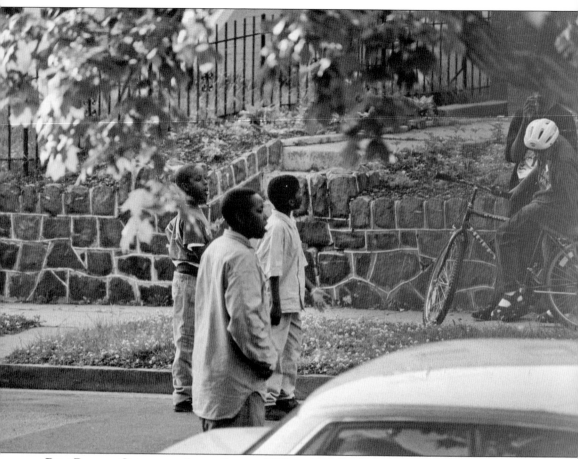

BOYS PLAYING OUTSIDE ON ADAMS STREET, NW, IN 1995. In the mid-1990s, Emmanuel Onwukwe set up a program to take the neighborhood children on a day trip to what is now Six Flags amusement park. The neighbors all pitched in, taking collections to gather money for this fun trip, and the children also made lemonade for the funds. Emmanuel got a couple of vans and some chaperones, and all the children in the neighborhood would go on their yearly summer trip. He also set up a couple of boys to help work on a small arts and crafts project with some African carvings. Those teens later stated that these activities kept them out of trouble. (Photograph by Jenifer Simpson.)

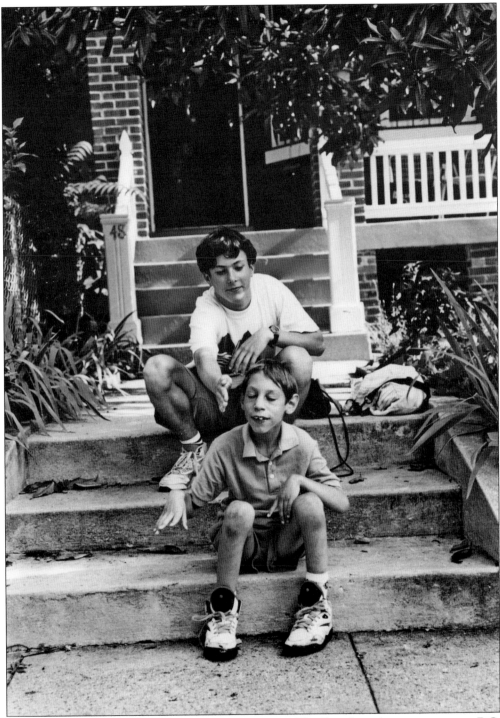

JOSHUA WITH A FRENCH EXCHANGE STUDENT IN 1994. The French students came over to D.C. for a summer exchange program. They were able to learn some more English while their hosts learned a little more French. (Photograph by Jenifer Simpson.)

DeJuan (10), Bloomingdale Resident, 1996. Note the pixie queens and irises blooming in the background. (Photograph by Jenifer Simpson.)

Beatriz, Geronimo, and April Gates (now deceased), **Children of Bloomingdale.** Beatriz is now a recruiter with the U.S. Air Force. (Photograph by Jenifer Simpson, 1996.)

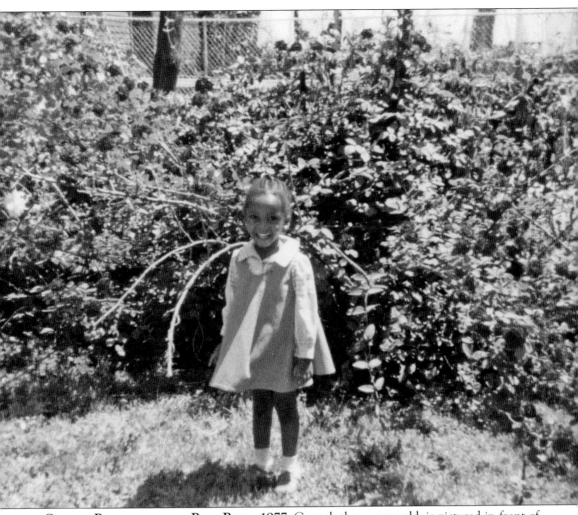

CRYSTAL BARNES AND THE ROSE BUSH, 1977. Crystal, three years old, is pictured in front of beautiful roses, one of the many flowers identified with the beauty of Bloomingdale. (Photograph by D. Barnes, former Bloomingdale Civic Association president.)

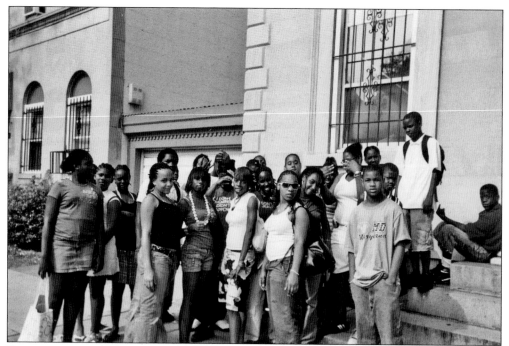

ECKINGTON NEIGHBORHOOD. A group of young people from Seaton Place in nearby Eckington is pictured in front of St. Martin's Church in Bloomingdale in August 2006. The neighborhoods of Bloomingdale and Eckington often interact with one another.

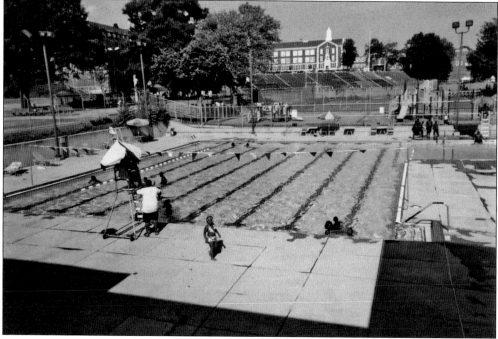

ECKINGTON SWIMMING POOL, SEPTEMBER 2006. The pool is where Bloomingdale children often go swimming. Joseph Gales bought the land later known as Eckington in 1815 and built his first two-story structure in 1830.

ROW HOUSES IN BLOOMINGDALE, 1995. Harry Wardman also built row homes in Columbia Heights, Eckington, and Brightwood. Wardman homes are known for their excellent craftsmanship, construction, and materials. The house shown here is located on First Street, NW.

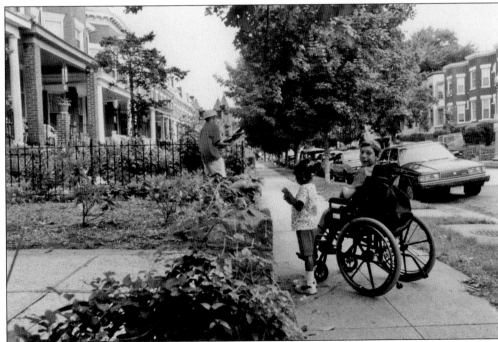

ROW HOUSES ON ADAMS STREET, NW, IN BLOOMINGDALE. The typical picturesque row house to the right has been used as inspiration for some local artists. Joshua, David, and Nnenna are pictured.

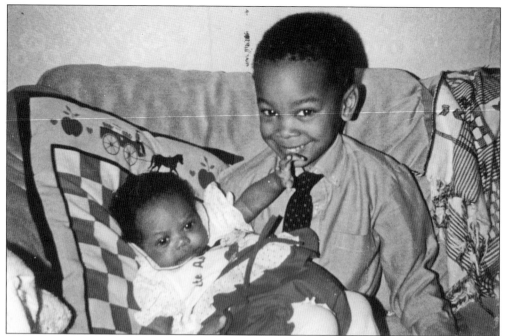

DAVID AND NNENNA. David was three years old and Nnenna was two months when their father, Emmanuel Onwukwe, took this photograph. The Onwukwe family moved to the neighborhood in January 1990, when it was going through a great deal of crime. Although the family was very skeptical about moving initially, the beauty of the house, its woodwork, and neighborhood won them over.

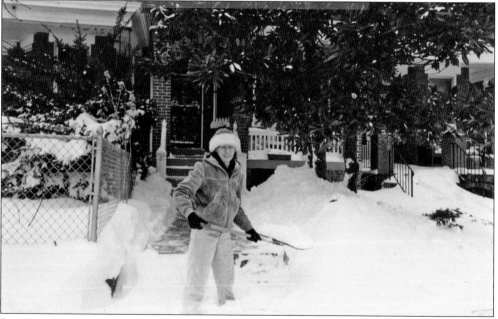

JENIFER AND THE SNOW, 1996. Jenifer tackles the snow in Bloomingdale right after the blizzard of 1996. The district was not prepared for the massive snowfall, and as a result, it took several days before the roads and side streets were cleared.

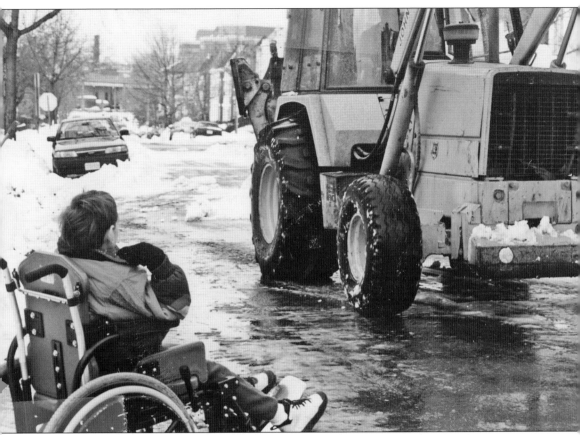

JOSHUA AND THE SNOWPLOW. Joshua watches the snowplow after a serious snowstorm in 1992. The Bloomingdale neighborhood ground to a stop as cars were buried in the snow, and it took several days for the plows to come around to the neighborhoods. (Photograph by Jenifer Simpson.)

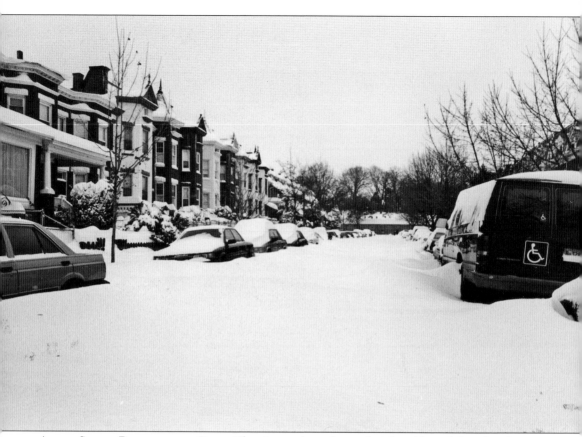

ADAMS STREET BURIED UNDER SNOW. The city was brought to a halt by a blizzard that shut down the eastern United States in 1996. Besides wind, snow, and ice, the district had freezing temperatures that shut the city down. The snow that fell during the blizzard of 1996 had heavy wind gusts, whiteout conditions, lightning, and thunder. The snow began on Saturday evening, January 6, and it continued for another day. Snow totals measured from 13 to 17 inches. (Photograph by Jenifer Simpson, 1996.)

THE BARNES FAMILY IN 1986. The Barnes family has lived in the neighborhood for over 30 years and watched changes occur over the decades. James Barnes recently passed away.

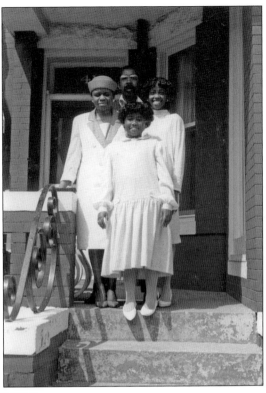

BLOOMINGDALE IS KNOWN FOR ITS BEAUTIFUL ARCHITECTURE AND HISTORIC HOMES. The architects paid special attention to detail, and the builders have passed this skill down from generation to generation, teaching the younger builders.

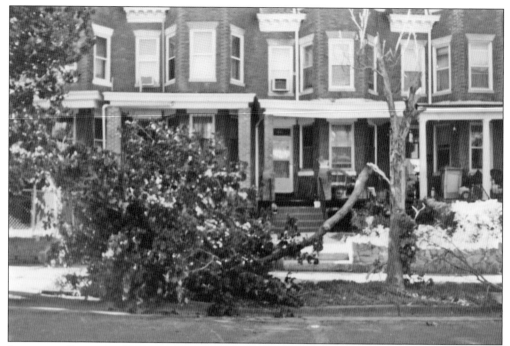

LIGHTNING STRIKES IN BLOOMINGDALE. A huge lightning storm hit this oak tree. The city replaced this tree with a new one. Old-timers state that Adams Street was lined with huge oak trees and was more like an avenue.

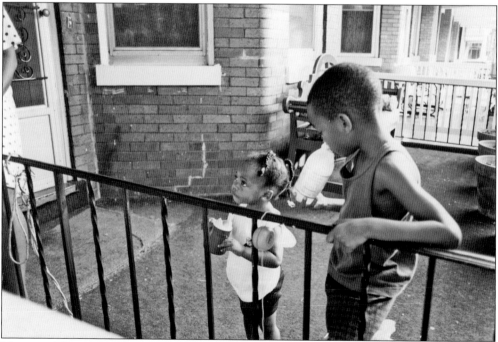

NNENNA (2) AND DAVID (5) IN BLOOMINGDALE. The brother and sister relax on the steps in Bloomingdale. The porches in the rear go as far as the eye can see, lending to the scene a very relaxed, neighborly feel.

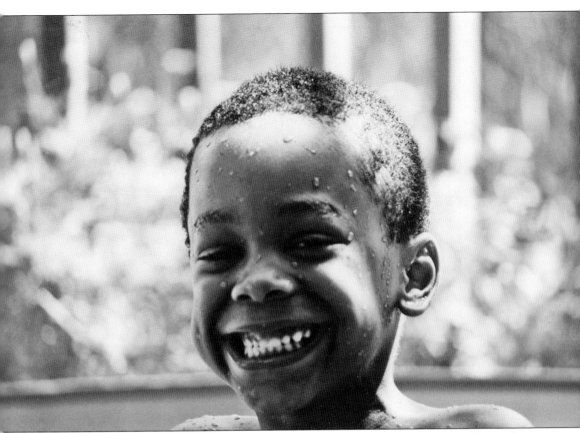

DAVID ENJOYING A DIP IN BLOOMINGDALE, SUMMER OF 1994. Washington, D.C., is known for its hot and humid summers with sweltering heat. David, one of the Bloomingdale residents, enjoys cooling off in a mini pool.

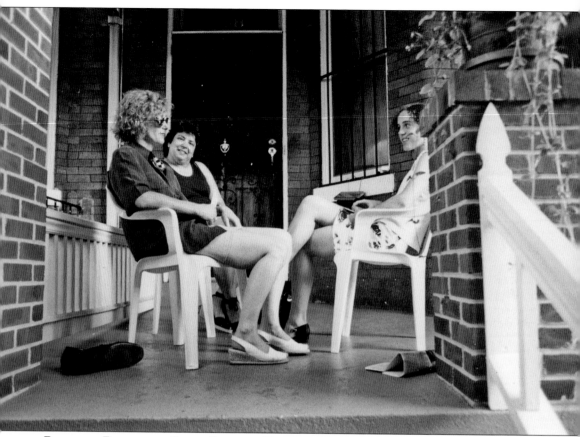

Residents Relax on a Front Porch in Bloomingdale, Summer of 1994. Shown here are, from left to right, Evelyn Girad (visiting from Paris, France); Ann Sankes, a registered nurse; and a friend. The neighbors on this block are known for borrowing salt, flour, eggs, and other items and passing them to each other over porch fences. Due to the close proximity of the row houses, many neighbors struck up close friendships with each other. The residents in Bloomingdale prided themselves on their front porches, planting flowers in flower boxes and containers and decorating their porches with tables, chairs, and benches.

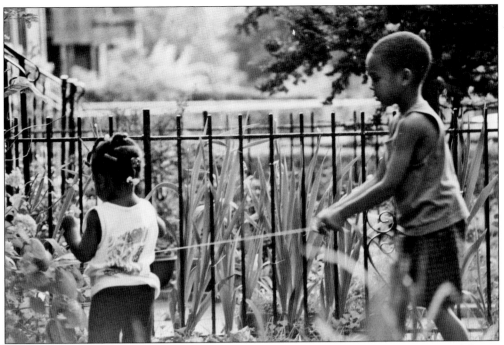

CHILDREN PLAYING IN A GARDEN IN BLOOMINGDALE. The neighborhood of Bloomingdale is a residential and friendly place where children play in their yards.

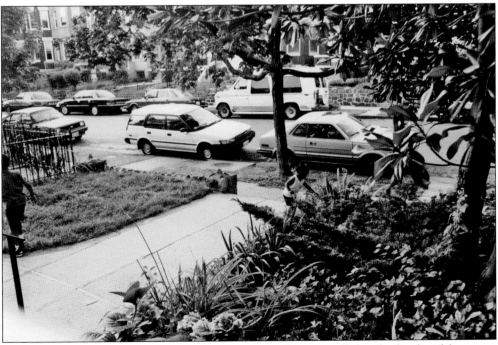

FRONT YARDS AND STREETS IN BLOOMINGDALE, 1998. Cars generally line both sides of the streets while two-lane traffic goes in between. Most residents park their cars directly in front of their homes or nearby.

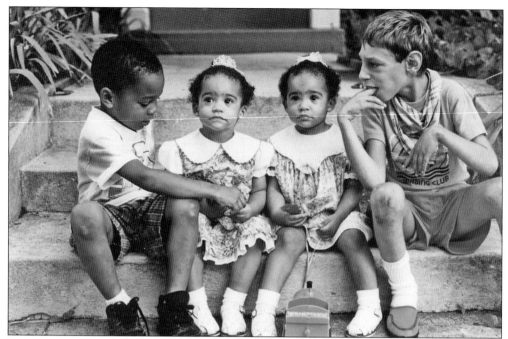

CHILDREN IN BLOOMINGDALE RELAX OUTSIDE ON A NICE DAY, 1993. From left to right are David, twins Courtney and Carissa Lundquist, and Joshua Charienitz. The children in Bloomingdale enjoyed playing for hours outside together during good weather.

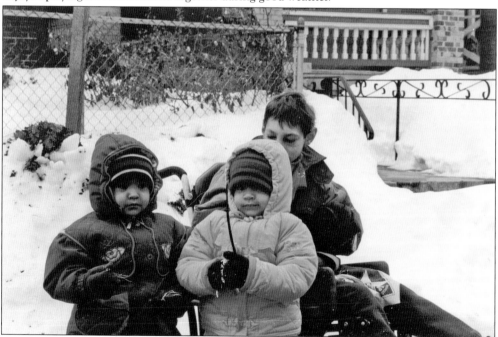

TWINS COURTNEY AND CARISSA WITH JOSHUA. During the blizzard of 1996, the entire city, including Bloomingdale, came to a halt, and the snow, wind, and ice crippled the city. Parents scrambled to keep their children from becoming stir-crazy and bundled them up to get some fresh air from time to time.

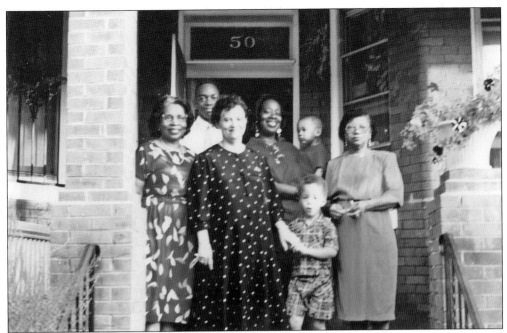

BABY SHOWER IN BLOOMINGDALE. From left to right are Lillian Durodola, now a minister at Second Baptist Church in southwest D.C.; James Durodola III, an attorney in Boston and North Carolina; Caroline Fletcher, an executive housekeeper at the Metropolitan Club; Brian Tate, now a salesperson at Best Buy; Rosemarie Onwukwe carrying David Onwukwe, now a college student; and Molly Onwukwe, now retired and living with her youngest daughter in Maryland. They are gathered at a baby shower in Bloomingdale. The photographer, Helen Akparanta, is the assistant attorney general for the Maryland Department of the Environment.

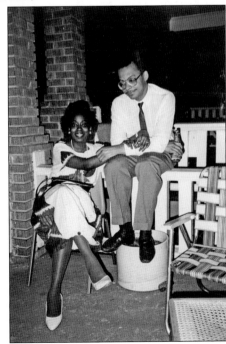

ROSEMARIE ONWUKWE AND EMMANUEL ONWUKWE. The couple relaxes on the deck in Bloomingdale in the early 1990s. Rosemarie and Emmanuel lived in the Bloomingdale neighborhood together for over 15 years before his untimely death in 2005.

THE CHARLES FAMILY. The Charleses moved into the neighborhood several decades ago. Mark Charles and some of his siblings grew up in Trinidad and moved back to the States in the 1950s and to Adams Street, NW, in Bloomingdale in the 1970s. Mark is a psychiatrist and lives in Santa Ana in Orange County, California. (Courtesy of the Charles family.)

CHARLES GRANDCHILDREN. In this family picture taken in Bloomingdale, are, from left to right, (first row) Camille and Shandy; (second row) Norman Jr. and Marie. (Courtesy of the Charles family.)

JALITA CHARLES AND BABY KHAMIL IN THEIR BLOOMINGDALE HOME. The beautiful woodwork is featured prominently in many homes in the neighborhood. Jalita Charles is now a successful real estate agent. (Courtesy of the Charles family.)

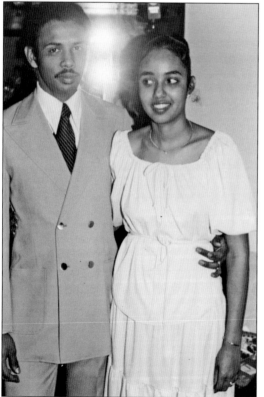

NORMAN AND SISTER JALITA CHARLES, 1971. Norman served with the Marine Corps from 1978 to 1980 and then worked for the U.S. Postal Service police force for more than 25 years. (Courtesy of the Charles family.)

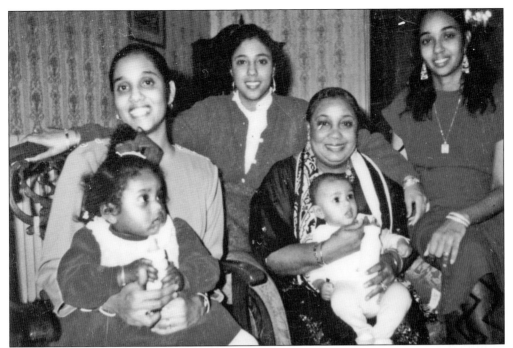

CHARLES FAMILY MEMBERS SPAN GENERATIONS. From left to right in the 1970s, Marina, Jameela, Jalita, and Gloria Charles (deceased) are pictured with other Charles family members including babies Zamina Zaboo and Mark Latimer. Gloria Charles was a strong family matriarch who was known for her beautiful gardens and her compassion for the neighborhood cats. (Courtesy of the Charles family.)

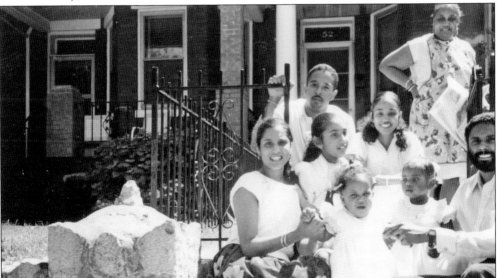

FRONT YARD AND THE CHARLES FAMILY ON ADAMS STREET, EARLY 1970S. The Charles family kept this home in the family for over 50 years. The matriarch of the family, Gloria Charles, standing in the rear, had weekly family get-togethers and picture-taking sessions. She took care of the many alley cats that prowled the neighborhood and fed them; as a result, Adams Street was always free of little critters. (Courtesy of the Charles family.)

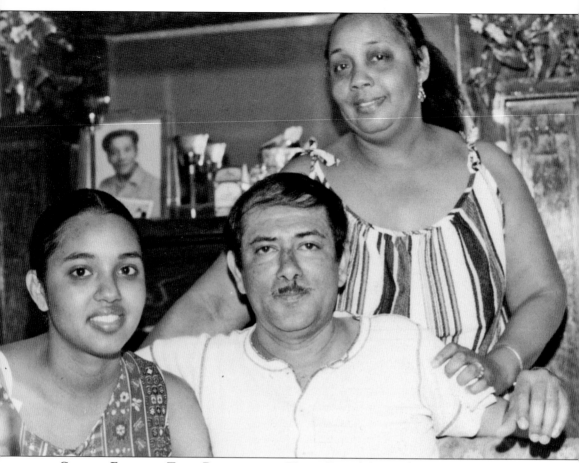

CHARLES FAMILY IN THEIR BLOOMINGDALE HOME. From left to right are Jalita Charles, David Charles (deceased), and Gloria Charles (deceased) around 1972. A photograph of Gloria's mother is visible in the background.

MARINA CHARLES IN HER BLOOMINGDALE HOME, 1972. Marina now lives in Maryland and has two grown children who spent a large amount of their childhood enjoying the Bloomingdale neighborhood.

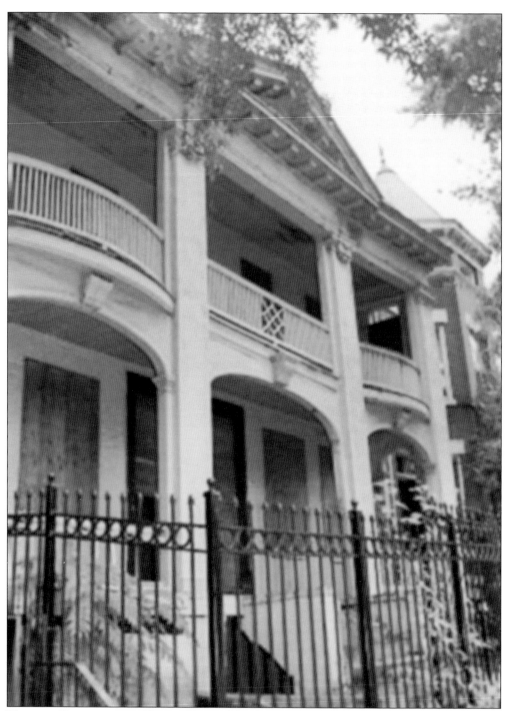

HISTORIC BLOOMINGDALE HOMES. Houses like the one pictured here were built with precision and accuracy and were able to stand the test of time. Bloomingdale is proud to host annual home tours, where residents and guests can visit some beautifully designed homes in Bloomingdale. Homes like this one are the reason why the tours are very well attended. (Photograph by Jason Miccolo Johnson.)

GAGE SCHOOL. Historic Gage Eckington Elementary School still creates a buzz, as the property is still very much in demand by the city.

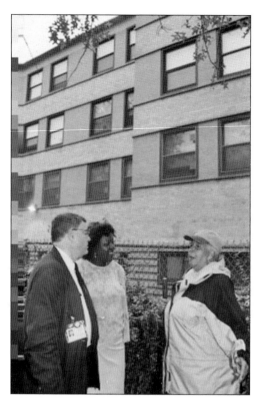

BLOOMINGDALE WALKTHROUGH.
Bloomingdale past president Cleopatra
Jones, a former president of Washington
Hospital Center, and a Bloomingdale
resident talk about the neighborhood
during a walkthrough. The group is
chatting outside one of the Howard
University dormitories. (Photograph
by Jason Miccolo Johnson, 2000.)

MAYOR, A BELOVED PET. Mayor, aged 15,
is a family member of Victoria Leonard,
a Bloomingdale resident and director of
policy and strategic communication for the
office of council member Harry "Tommy"
Thomas Jr. Mayor joined the family in the
summer of 1996 as puppy when Victoria
and her dog Blackie (now deceased)
found him on the Gage Eckington School
playground. Mayor likes to eat, sleep, and
steal food from the cats. He generally just
walks around the block but also loves to
visit their neighbors Joe and Jim at 111 W
Street and especially enjoys their doggie
parties. His best friend is Victoria's cat
Jessica, who is 16 years old and blind.

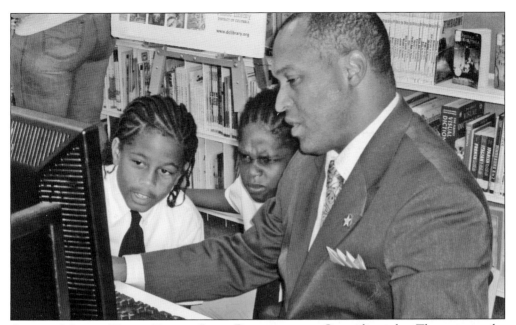

COUNCIL MEMBER HARRY THOMAS JR. IN BLOOMINGDALE. Council member Thomas won the Ward 5 council seat in November 2006 and was sworn into office in 2007. Council member Thomas is also chair of D.C. City Council on Libraries, Parks, and Recreation. In addition, he sits on two other committees: Government Operations and Health and Workforce Development. Here council member Thomas is shown with two D.C. public school students.

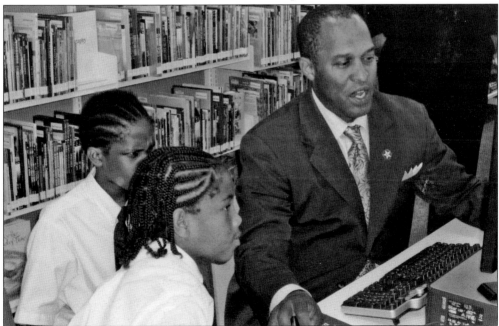

COUNCIL MEMBER THOMAS ACTIVE IN BLOOMINGDALE. Council member Thomas has always been active in the Bloomingdale neighborhood and attended many events. He has set up some series titled Council Member on Your Corner in the summer of 2009 where he met the residents of Bloomingdale in the neighborhood. He is pictured in another shot with D.C. students.

VISITING THE NEIGHBORHOOD. Council member Thomas and former mayor Marion Barry visit local residents in the neighborhood.

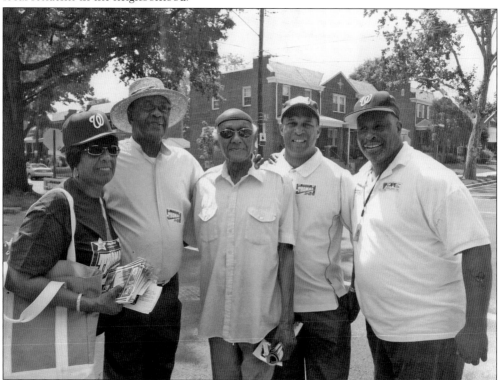

BEAUTIFUL DAY IN THE NEIGHBORHOOD. Pictured here are, from left to right, Grace Lewis, former Washington mayor Marion Barry, council member Harry Thomas Jr., and Jeff Camaly.

THE AUTHOR AND CONTRIBUTORS

Jason Miccolo Johnson is a nationally known award-winning documentary, editorial, and fine art photographer. The native Memphian is a Howard University alumnus who perhaps is best recognized for his trademark "visual call-and-response" shooting style with poignant images that focus on the subject's eyes and hands. Nowhere else is this more evident than in his book and national traveling exhibition, Soul Sanctuary: Images of the African American Worship Experience, which Gordon Parks called a "magnificent collection" of images.

Suzanne Des Marais is an artist living and working in Bloomingdale. In addition, Suzanne is a real estate broker and has introduced many homeowners to the Bloomingdale neighborhood. She is a frequent contributor to the neighborhood listserv and local blogs.

Jenifer Simpson has lived in the Bloomingdale section of Washington, D.C., for over 25 years. When she is not working downtown as a lobbyist at a nonprofit national association, she can be found puttering in her garden or finding ways to serve at the Church of the Resurrection on Capitol Hill or helping improve the community. She was a cofounder and editor for the Adams Street Newsletter with Rosemarie Onwukwe and has joined several "Orange Hat" teams that work to lessen crime and build up the neighborhood. Ms. Simpson has a bachelor's degree in art and a master's in business administration and takes many photographs in her spare time.

Rosemarie Onwukwe is a Bloomingdale resident who moved reluctantly to the neighborhood 25 years ago and fell in love with it. She is a freelance writer who is interested in her community and is the mother of two teenagers. She was the cofounder of the Adams Street Newsletter in Bloomingdale.

Rosemarie has a bachelor's degree in mass media and a master's degree from George Washington University in bilingual special education. She loves reading, meeting new people, and going to her favorite gym—the DCJCC. She is very active in her church, Israel Metropolitan CME Church. She is surviving widowhood.

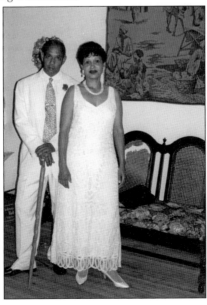

www.arcadiapublishing.com

Discover books about the town where you grew up, the cities where your friends and families live, the town where your parents met, or even that retirement spot you've been dreaming about. Our Web site provides history lovers with exclusive deals, advanced notification about new titles, e-mail alerts of author events, and much more.

Arcadia Publishing, the leading local history publisher in the United States, is committed to making history accessible and meaningful through publishing books that celebrate and preserve the heritage of America's people and places. Consistent with our mission to preserve history on a local level, this book was printed in South Carolina on American-made paper and manufactured entirely in the United States.

This book carries the accredited Forest Stewardship Council (FSC) label and is printed on 100 percent FSC-certified paper. Products carrying the FSC label are independently certified to assure consumers that they come from forests that are managed to meet the social, economic, and ecological needs of present and future generations.

FSC
Mixed Sources
Product group from well-managed forests and other controlled sources

Cert no. SW-COC-001530
www.fsc.org
© 1996 Forest Stewardship Council

Find Your Place in History.